The Ballerina and the Bull

The Ballerina and the Bull
Anarchist Utopias in
the Age of Finance

Johanna Isaacson

Published by Repeater Books
An imprint of Watkins Media Ltd

19-21 Cecil Court
London
WC2N 4EZ
UK

www.repeaterbooks.com
A Repeater Books paperback original 2016
1

Distributed in the United States by Random House, Inc., New York.

Cover design: Johanna Isaacson and Johnny Bull
Typography and typesetting: Jan Middendorp
Typefaces: Chaparral Pro and Absara Sans

ISBN: 978-1-910924-10-5
Ebook ISBN: 978-1-910924-11-2

Contents

*All citations are in MLA format. Page numbers appear in parentheses.
Authors' names are either in text or in parentheses.*

Introduction

No Future

From the uprisings in Seattle in 1999 to the Occupy move-
ment of 2011, our moment has seen a resurgence of an
anarchist sensibility. Against the vacuity and drift of finan-
cialized capitalism, these insurgent movements have
insisted that an alternative is possible. But the idea of pos-
sibility itself, and the ability to maintain a stable boundary
between utopia and dystopia, shifts in an age of historical
breakdown. As Fredric Jameson has recently argued, "the
power of the negative" is intensified in our new moment of
historical crisis — "an ominous perpetual present in which
no one knows what's coming... and indeed no one knows
whether anything is coming at all" ("On the Power"). This
book makes a wager for jerry-rigged, DiY practices, social
experiments, quixotic contestations against the capitalist
behemoth that allow us to see the limits and hopes of our
largely depoliticized moment. DiY offers an alternative to a
narrative that says we have arrived at the end of history and
that there is no alternative to the isolation and alienation of
capitalist individualism. The title of this book, *The Ballerina
and the Bull,* refers to the initial call for Occupy Wall Street in
the pages of anti-corporate *Adbusters* magazine, which fea-
tured an image of a simply dressed ballerina perched on the
symbol of Wall Street, a rearing bull. While *Adbusters* framed
this as a kind of triumph of the ballerina over the bull, I take
the dynamism of this duality as an emblem of the genera-
tive relationship between the prefigurative, utopian actions
of anarchists as they come up against economic and social
limits to transformation. This tension itself is a rich point of
entry into political-cultural dilemmas and potentialities of
our spectacular moment.

Periodizing the Present

With some reluctance, I am calling contemporary DiY "postmodern," which, with Fredric Jameson, I see as interchangeable with "late capitalism." Other interpretations of postmodernism see it as a post-Marxist moment. However, I follow Ernest Mandel's periodization of "late capitalism" which suggests that capitalism has mutated and adapted to crises, rather than waned, becoming "if anything, a purer stage of capitalism than any of the moments that preceded it" (Jameson, *Postmodernism* 1). In this stage of late capitalism, the appearance of endless choice and endless identity positions creates the need for intensified scrutiny, modes of thinking that aim not at providing answers but at figuring out the questions to ask. Contemporary anarchism correlates to post-Sixties logic, as Jameson frames it, in which the "unbound energies which gave the sixties their energy" were harnessed to a new stage of global capitalism, giving way to an expansion of proletarianization and its resistance ("Periodizing the Sixties" 108-109). Looking at these struggles as both theory and practice offers us a point of purchase from anti-utopian, neoliberal "capitalist realism."

This navigation of contemporary byzantine forms of reality requires the category of mediation and an epistemology that is able to move beyond surface phenomena. Although the category of the proletariat may seem outdated in a moment of widespread first world deindustrialization, I want to argue that a messily grouped emergent precariat, a word which I'm using, following Aaron Benanov, as a placeholder for a multi-levelled and differentiated workforce that is nevertheless affected deeply and systematically by precarity, has the potential to occupy this standpoint from which mediation is accessible. The precariat can be seen as the majority of the globe's occupants: those who lack a social contract with the welfare state, lack trust relations with capital, lack labor

security, lack reliable and consistent status positions and attachments (Standing 10). This precariat has a special place in relation to knowledge, a standpoint from which it can embody both the position of a subject and an object. The standpoint of the precariat allows some purchase on immediacy and facticity by refusing to let facts stand for themselves, and instead interrogating the values of the society in which those facts exist. At stake in the concept of precariat epistemology against the empirical standpoint of power is an understanding that social relations aren't only as they appear and are vulnerable to change.

The anti-utopian periodizations that frame the present as "the end of history" devolve from this empirical logic which accepts the facticity of power relations and cultural values unquestioningly. What Mark Fisher calls "capitalist realism" demands that we accept the present as eternal. The standpoint of the precariat keeps open the idea that static, fetishized forms of history and commodified life contain clues to the relationships which make social realization impossible under capitalism, and that the knowledge of these relationships is an essential element in transformation and realizing the possible. As zinester Johnny Sunset notes, "By the very definition of who and where we are, we are made to imagine the possibility of a lawless world" (7).

In this moment, subsumed by globalized capital, representation and aesthetics play a key role in providing what Alberto Toscano and Jeff Kinkle call "cartographies of the absolute." This representational mapping, however, takes the form of negation, the gauging of that which is by definition invisible. This book looks at the way that DiY maps these disappeared and marginalized spaces and logics. I argue that anarchist utopian projects can be read simultaneously for their prefigurative and cognitive aspects. In both of these registers there is a shift from the emphasis on the proletariat and its context of the factory to the post-industrial precariat and its urban milieu. Here, the prob-

lem of representation is diagnosed in postmodern city-dwellers' inability to map their own sense of place.

Implied in this dual view of anarchist utopia is also a critique of anarchist self-perception. Recognizing the limits and horizons of direct action does not constitute pessimism or cynicism. In fact, it does the opposite. A self-critical view of anarchist utopia along with a foregrounding of political economy allows for a true optimism that structural change is possible. This optimism in what I am calling DiY's "expressive negation" counters the pessimistic narrative of "the end of history" in which the perpetuity of capital is naturalized and seen as inevitable. This form of complacent "realism" finds its rhetorical center in a discourse of "maturity" set against an irresponsible youth culture. While there is nothing inherently revolutionary about the category of youth, and indeed, this figure can be seen to have analogous characteristics to a hedonistic stage of commodity capitalism in which consumerism and culture eclipse the serious business of building new social relations, a simplistic critique of youth and political passion will not suffice in an age of enforced austerity. The rise of austerity as an antagonist should teach us that "maturity" is a central "ideologeme of the right" used to coerce the global precariat to participate in her own oppression. The postmodern foreclosure of the concept of utopia and the narrative that foregrounds "the end of grand narratives" came at the price of an attenuation in the scope of political and historical vision. We should instead analyze youth culture generously with the goal of resurrecting and broadening struggle, following Marx's thesis on Feuerbach: Philosophers have hitherto only *interpreted* the world in various ways; the point is to *change* it.

In its focus on overcoming the separation between the aesthetic and the everyday, DiY brings back a logic that values the concept of totality. This is an undervalued aspect of DiY practice, known primarily for its idealism, its post-structuralist influences, and its inattention to political economy (Clover "The

Coming Occupation"). I'm arguing, instead, that anarchism does have the capacity to draw our attention to political economy and it is for this reason that the primary antagonist in this book is pragmatism. DiY negation provides a critical rather than pragmatic view of politics. Activity, praxis, and refusal are here set against an increasingly homogenized, passive, abstract, contemplative, image-saturated world where, as Guy Debord argued, separation is perfected.

This condition cannot be voluntaristically transcended. Insofar as political projects create "alternatives" without taking into account the larger trajectories and limits of capitalism, they will fall into the ideological trap Greg Sharzer attributes to "localism," the notion that local projects, such as the creation of organic gardens, constitute a viable political strategy. There is no unmediated means for DiY subculture to wave a magic hoodie and smite the angel of history. And yet, the agility, the brilliance, and the militant optimism of anarchist expressive negation exceeds its own symptomaticity and gracefully eludes the dour scolding of political pragmatists.

What are the Politics of Style?

This book assumes that DiY cannot fully transcend its subcultural roots, the politics of style. Even DiY involvement in political actions such as the 1999 "Battle of Seattle" and the Occupy movement are moments of mediation and representation as well as action. These movements directed a critical gaze at global capitalism, naming and denaturalizing an increasingly opaque system of power. Such power to name and to stand up to capitalism goes against the idea made popular by Frances Fukuyama, that we have arrived at the end of history and should concede any battle against the best of all possible worlds. This posits that the late 20th century signifies a triumph of economic and political liberalism, with

every alternative entirely played out. Here, inequality is seen as simply the remainder of older social formations such as the racial legacy of slavery. For Fukuyama, pragmatism must take the form of a strong anti-utopianism that sees the fall of the Soviet Union as having finalized the last serious alternative to liberal democracy. This is the finalization of what Margaret Thatcher referred to as TINA (There Is No Alternative), and demonstrates the stakes for thinking on a register other than the "pragmatic." Expressive negation allows for a narrative of "failure" that does not converge with an anti-utopian logic that dismisses all practices and discourses aiming at systematic transformation.

With the anthem "no future", DiY activity is actually insisting there is a future, a possibility of transformation beyond this state of capitalist crisis. The power of the negative in DiY is a form of realism about mediation in the face of an intractable society of the spectacle. That is, the politics of style are most productively framed as a politics of historical materialism set against what Mark Fisher calls "capitalist realism," a naturalization and sedimentation of the logic of contemporary capitalism creating a context where, in a phrase commonly attributed to Fredric Jameson, it is easier to imagine the end of the world than it is to imagine the end of capitalism. In the face of this impasse, capitalist realism consists of dead and quantified cultural monuments incapable of merging with or transforming the lifeworld in a moment devoid of the new (Fisher 3). This capitalist realism, characterized by the "deflationary perspective of a depressive who believes that any positive state, any hope, is a dangerous illusion," is countered by a punk affect of anger, a permeating urge to destroy, which demands the impossible while maintaining a realism about impasses in contemporary cultural innovation (4).

The politics of style are, then, the politics of mediation. This is particularly evident in the DiY *"détournement"* of

commodities. If the commodity form is all-pervasive in a moment of late capitalism, commodities themselves are two-fold, both displacing and containing the social relationships denied to people in their daily lives. Dick Hebdige begins his analysis of DiY subcultural politics of style with a focus on objects — a tube of Vaseline, a safety pin. In subcultural practice the mundane object becomes a sign of refusal or an estrangement of commodity forms, so that they are no longer taken for granted as natural. By recognizing the range of potential meanings in the commodity, DiY opens channels for resistance. This is a factor in the ongoing struggle between representatives of power and the precariat to frame and understand the world around us. So the politics of style in postwar youth subculture points to an unraveling of consensus and an opening of critical awareness.

The politics of style implicit in the subcultural reuse and recombining of mundane objects is *détournement*, a practice begun by the Situationist International (SI), a group of militant artists and intellectuals instrumental in the Paris revolt of 1968. Experiments in *détournement* came about as a response to the increasing complicity of artistic expression in systems of powers focused on "creativity" and media. Hoping to avoid the pitfalls of recuperation (the absorption of radical ideas and culture into hierarchical societal norms) and the impossibility of originality, the SI opted for a process of research and propaganda. The situationist movement resists the dictum that art should "show not tell," and instead aims to infuse expression with an explicitly political, pedagogic, and critical mode.

This struggle for expressive negation through *détournement* has been popularly exemplified by the band Negativland's pioneering and controversial use of collage in their music. The band describes their legal battle to sample and redeploy music as related to a radical political strategy that

uses humor to navigate complexity rather than divide politics into crude "black and white" dichotomies (Sinker 225). Negativland, a punk band but an anomalous one, is characteristic of the examples I will refer to in this book. The writers, musicians and activists whose forms of expressive negation give insight into and provide weapons against "capitalist realism" are often slightly off the nose of punk doxa.

These forms of punk recognize and negotiate the impossibility of fully escaping the commodity form. Punk's subversion stems from its appearance as threat, representing both emergence and repression of political desire in mass culture. The politics of style, then, is not an escape from symptomaticity (inevitable conforming to the logic of one's historical moment), but an exploitation of openings, contradictions and emergence through an immersion in the dominant modes of commodification, or as the SI puts it: "the cheapness of its products is the heavy artillery that breaks through all the Chinese walls of understanding."

Anarchism: US Style

The politics of style in DiY is inextricable from the politics of anarchism. DiY's focus on culture, subjectivity, and anti-electoral politics partially explain this alliance. Another element is the historical shift away from communism with the dissolution of the Soviet Union in the late Eighties, and the unraveling of worker-centered politics in an age of deindustrialization. For these reasons, anarchism emerges as a significant form of political expression in our moment. However, it's important to keep in mind a longer narrative of anarchism as source and influence on contemporary practices. Most of the DiY projects considered in this book are US-based and are informed by the currents of anarchism that developed from the late 19th century.

In early individualist anarchists such Josiah Warren and

Benjamin Tucker, the ideas of Max Stirner and Pierre Joseph Proudhon mingled with native Jeffersonian and Thoreauvian utopianisms to form the first visible anarchist presence in the US. With the depressions and strikes of the late 19th century, some members of immigrant radical socialist groups, such as the Socialist Labor Party (SLP), became increasingly disillusioned with electoral politics, turned to revolutionary socialism and then, inspired by the first anarchist international and the arrival of Johann Most in America, turned to anarchism. The revolutionary splinter group from the SLP, the International Working People's Association (IWPA), gained up to six thousand members and was a central militant force in the Eight-Hour Movement of 1886. The Haymarket incident and its repercussions cut this momentum short. However, figures such as Johann Most continued to speak and circulate pamphlets advocating social revolutionary approaches to anti-capitalism.

Most of the participants in these early anarchist formations could be classified as anarcho-communists whose ideology was characterized by a subscription to the Russian revolutionary Mikhail Bakunin's theory of the state and his communistic bent. They considered their goal to be communism, but differed with socialists on tactics, and felt that sabotage, direct action and the general strike were the appropriate means of revolutionary change. However, these ideas mingled with the influence of such individualists as Stirner in the ideology of prominent anarchists such as Emma Goldman and Voltairine de Cleyre. Whereas individualists like Tucker opposed insurrectionary tactics, Goldman championed a social revolutionary, syndicalist approach to liberation, but framed many of her arguments for anarchism in terms that lay more stress on the individual than the collective, as evidenced in her essay "Minorities versus Majorities." In the work of Voltairine de Cleyre this mingling of strains of anar-

chism led to an initial identification with Benjamin Tucker, but eventually turned to focus on anti-imperialism and solidarity with the Industrial Workers of the World (IWW), and a subscription to "anarchism without adjectives."

The syndicalism of the IWW derived from an amalgamation of anarchist and socialist thought. They forged class consciousness in this period of rapid industrialization through the inclusion of African Americans and immigrants. Some of the philosophy of anarcho-syndicalism can be seen in the earlier work of Rudolf Rocker, who locates the central tenets of anarcho-syndicalism as antimilitarist propaganda, economic boycotts, armed resistance, and, as the trigger of revolution, the general strike. This form of syndicalism was able to mobilize class consciousness and make substantial gains in its support of the 1912 textile strike in Lawrence, and several other strikes. However, the imprisonment and deportation of its leaders, opposition from the American Federation of Labor, and the shift of the political climate with the US entrance into World War I led to its demise.

Following this period there was a lull in anarchism, which survived in such utopian educational projects as the Stelton School, and in such journals as *Road to Freedom, Adunata dei Refrattari*, and *Il Martello,* the Yiddish *Freie Arbeter Shtimme*, and in scattered social organizations of immigrant communities. In the Forties and Fifties anarchism appeared in pacifist groups and literary circles, in the establishment of Pacifica Radio, and in such journals as *Politics* and *Liberation*. These magazines were influential on the New Left and involved transitional figures such as Paul Goodman. The notion of "participatory democracy" in the early Students for a Democratic Society and the turn to consensus in projects such as the Economic Research and Action Project were anarchist influenced. The Lower Eastside Anarchists, spearheaded by Murray Bookchin, a former communist and a writer on eco-

logical issues, had a publication, *Anarchos*, which encouraged a focus on personal lifestyle issues and which rejected the focus on imperialism and class that was advanced by the more Marxist influenced left.

In the Sixties anarcho-syndicalist ideas were espoused in *Black and Red* publications and in *Fifth Estate,* which were linked to the former artists turned "street gang with an ideology," the Motherfuckers. Fredy Perlman was influential on both journals and connected with the French situationists, whose anarchism focused on the imbrication of daily life and the commodity form, and the role of the state in this process, as well as on insurrectionary means to combat alienation. US situationists such as Point Blank leveled critiques at the reification of activism and violence evident in the student movements. Anarcho-syndicalism also had an influence on later waves of the New Left such as "Prairie Power." This can be seen in Carl Davidson's manifesto, "Towards a Student Syndicalist Movement." New Left journals such as *Radical America* were also influenced by anarchism. Additionally, with the expulsion of libertarians from the Young Americans for Freedom (YAF) and the influence of science fiction writer Robert Heinlein, a right-wing anarchism merged with the counterculture.

After the Sixties, US anarchism primarily survived in the ecology movement. This was influenced by Murray Bookchin's eco-anarchism and in the anarcho-feminism developed in the early women's movement, and can be seen in organizations such as Friends of the Earth, the Clamshell Alliance, and the Abalone Alliance. The writings of Dave Foreman and Edward Abbey and the concept of sabotage or "monkeywrenching" influenced Earth First!, at that time a nativist anarchist movement that subscribed to a form of eco-anarchism more related to the rugged individualism of early 19th century anarchism than the feminist

breed. A later generation, more related to the new social movements, brought eco-feminism to Earth First! While Bookchin, in his later development of municipal anarchism, rejected the "lifestyle" anarchism that he earlier espoused for a "social anarchism," which has little relationship to the class consciousness of anarcho-syndicalism and rather draws on organic metaphors to construct a view of revolution.

The subjects of Bookchin's attack on "lifestyle activism" were Hakim Bey, John Zerzan, David Watson and, implicitly, Bob Black. For Bookchin, these anarchist theorists were all lumped together under the Stirnerite tradition of individualism. In contrast, Bookchin asserted he had inherited the legacy of communal anarchism (in its post-scarcity, post-class form). These authors were all differently related to primitivism, a theory that centers around the refusal of work, as well as an "anti-civilizational" myth of the "hunter-gatherer" as "The Original Affluent Society," based on work by anthropologist Marshal Sahlins. These authors' relationships to technology differ, with Zerzan in favor of a neo-luddism and Hakim in favor of subversive action that makes use of technology. Authors such as David Watson, Fredy Perlman, and Bob Black subscribe to an "anti-civilizational" ideology, which looks to Paleolithic culture for inspiration, but does not actually suggest a regression to hunter/gatherer culture.

Second and third wave feminism, especially such phenomena as consciousness raising groups, drew from a long tradition of sexual freedom and feminism in anarchism. Free love, polyamory, birth control, and marriage laws were taken on by anarchist pioneers such as Emma Goldman, Voltairine de Cleyre, Lucy Parsons, the Spanish Mujeres Libras, Josiah Warren, and Emile Armand. In the Sixties and Seventies, anarcha-feminism became a prevalent mode of organizing women's liberation movements, with figures such as Susan Brown, Peggy Kornegger, and Carol Ehrlich claiming that

feminism was inherently anarchist and using anarchism as a form of negating what they saw as impasses in both socialism and feminism. Ehrlich developed an anarcha-feminism based on the situationist critique of Marxist forms of hierarchical structures. Kornegger saw anarchism as a way to interrogate not just patriarchal action, but patriarchal forms of knowledge that denigrate sensuality, intuition, and play as feminized forms of thought. Tactics such as spontaneity, direct action and small organizational units, collectives and consciousness raising groups, would serve to negate alienating modes of communication and sociality.

In the Eighties, US anarchism primarily stayed alive through environmental, feminist, punk, and neo-situationist channels, as well as through the direct action against US support of military dictatorships in Latin America and surrounding AIDS issues. Without the anchoring presence of the New Left, these strands transformed and merged. For example, the situationist-oriented organs such as *Fifth Estate* moved from a situationist to a primitivist position, as can be seen in one of Perlman's last writings, *Against History! Against Leviathan!*. Bob Black also straddles this position, advancing situationist-styled critiques of work as well as anti-civilizational polemics. These forms influence a host of anti-work zines such as *Processed World* and *Temp Slave*.

Since the fall of the Soviet Union and current transformations in global relations, other forms of radicalism have gained more visibility. Autonomous forms of anarchism, communization, and far-left communism have been active in Germany, Italy and England, giving rise to cross-fertilization in the form of internet journals and international actions. The widespread popularity of Hardt and Negri's *Empire*, for instance, forges a connection between Italian autonomia and the American grassroots movement. The Zapatista movement has been a great influence on contemporary forms of

anarchism; their militant and playful battle against both global capitalism and oppressive governmental forces inspire the ethos of the new revolutionary structure of feeling.

As a descriptive and prescriptive way of talking about DiY I will draw on its many links to and popularization of the theories of the French situationists who were linked to the Paris uprisings of 1968. The situationist dual focus on the transformation of everyday life and the critique of emerging logics of capital link to the duality I see at work in contemporary DiY practices, many of which directly cite situationist influences and more who are indirectly influenced by the group through punk culture or a generally diffused post-situ politics. The key critique that DiY inherits from the situationists is the notion that post-war developments have led to a passive "society of the spectacle" where human relationships have been displaced onto the relationships between images. This lead to an impoverished experience of the world, but for the situationists, this experience does not preclude the joy and hope for transformation that plays out in the creation of experimental spatial practices. Rather than nurturing nostalgia for pre-capitalist modes, the situationists saw capitalist development as creating a lag between reality and possibility for emancipation and free time that allows for sustained social desire. Referring to their projects as propaganda, the situationists refused specialization and the fantasy of impartiality, instead aiming for the unity of politics and aesthetics.

As with situationist practice, DiY actions are not focused on "survival" in the face of austerity, but rather denaturalize the category of austerity, showing it to be constructed and imposed on a society whose technological development has the potential to unleash abundance and possibility which is unevenly distributed in the current regime. This refusal of mere survival takes on what Henri Lefebvre calls the "possiblist" mode, as in the slogan "demand the impossible." Here,

unleashing desire is both a seizure of opportunity and a kind of representational realism. While postmodernism is often framed as a moment where the industrial proletariat has disappeared and therefore the revolutionary class has disappeared, the situationists argue that the expansion of capitalist logic into the everyday, leisure, and urban space expands revolutionary subjectivity to previously unthought-of categories such as youth and criminality.

DiY anarchism that continues this logic is a broad and loose category including all manner of projects that are conducted outside of state or corporate institutions. DiY includes activities such as permaculture and guerrilla gardening (planting gardens in vacant lots), Reclaim the Streets (impromptu festivals in which streets are shut down and turned into party spaces), punk subculture (including punk music, punk venues, punk squats, punk record distributors, punk zines, punk shops, riot grrrl and queercore), infoshops (all-volunteer Anarchist bookstores and lending libraries), and black bloc activism (masked protest cells attending economic summits and other capitalist events with the aim of shutting them down through obstruction and sometimes property destruction). DiY is a prominent contingent of global justice mass protests at the WTO, IMF, GATT, Republican and Democratic conventions, as well as the more recent Occupy movement.

"The new anarchism" is a term David Graeber uses to group together activists in the global justice and Occupy movements. The movement is anti-systemic and international, with a focus on a critique of borders, privatization, and austerity. Different aspects of the global justice and Occupy movements behave in different ways, but the DiY faction, composed of the black bloc and other anarchist leaning youth, do important symbolic work, tearing down fences and barriers, imagining what a world without borders might

look like. Graeber calls these tactics a "new language of civil disobedience, combining elements of street theatre, festival, and what can only be called nonviolent warfare" ("New Anarchists" 66). DiY politics signifies a new militancy and a resurgence of diagnostic focus on multinational institutions and corporations as targets of anti-capitalist opposition, while mobilizing the encampment and the commune as a form of spatial politics. There is focus on prefigurative politics in organization and communal rituals, such as consensus decision making and other forms of direct democracy. Graeber stresses the flexibility of the category of anarchist in new social movements; he paraphrases the philosophy as such: "If you are willing to act like an anarchist now, your long-term vision is pretty much your business" (72). This flexibility can be both a strength and a weakness. As George MacKay notes, this counterculture movement is a combination of "inspiring action, narcissism, youthful arrogance, principle, ahistoricism, idealism, indulgence, creativity, plagiarism, as well as the rejection and embracing alike of technical innovation" (2).

The years since the Occupy movement and the campus occupations that preceded it have seen an emergence of more theoretically defined forms of far-left politics in left communist and communization based groups such as the Endnotes collective, Theorie Communiste, and The Invisible Committee, that supply the movement with critical perspectives on political economy and the history of social movements. Here, I will engage with some of these theoretical perspectives, while focusing on an examination of the implied ideas of various DiY practices that may lack an explicit theoretical component. My theoretical take is not incompatible with communization theories, but it is coming from a different direction. Instead of imagining DiY as a potentially prescriptive political theory, I will look at how these practices

function discursively, to intervene in dominant rhetorics of maturity and austerity, and to refute the use of such pejoratives as "irresponsible" and "childish" to dismiss contestatory aspirations and budding social movements.

Mapping the Underground

I will begin exploring this culture by looking at its contestation of gentrification and the "revanchist city" in the chapter **"The hacienda must be built": DiY in the City.** DiY counterculture takes the city as both a site of oppression and contestation. This chapter explores the figure of the "punk *flâneur*," who gauges the fluxes and currents of urban life and, when openings arise, joins the struggle to reclaim the city. This figure is traced through a series of zines that develop a psychogeography of the financialized city: the popular Berkeley zine, *Despite Everything*; the San Francisco based zine *Iggy Scam*, which maps the utopian dimension of abjected realms and socialities in the city; the one-off travel-zine *Off the Map* that charts the utopian exploration of feminist punk space; and the UK zine *Savage Messiah*, as it insists on the affective and political registers of punk and their connection to ghettoized realms of the city.

From this exploration of DiY spatial practice, the book will investigate a more localized sense of space, making the case for the San Francisco Bay Area as an important influence on the shape of punk modernity. The chapter **A Rising Tide Sinks All Boats: Bay Area DiY** explores the shifts in counterculture in the Bay Area from an affirmative hippie subculture to punk "expressive negation," which maps the economic and political downturn of the Seventies and its effects on urban life. From the Dead Kennedy's lyrics and performance modes, to squatting, to the punk historian Erik Lyle's history of San Francisco, and the politics of "failure" in DiY small businesses, the chapter traces a long history of bohemia and resistance that

attempts to generate "counterpublic spheres," opening new temporal experiences in tension with the constraints of the capitalist city.

Chapter three, **Lineages of Expressive Negation in Feminist Punk and Queercore**, posits that DiY feminist and queer projects offer powerful sources of expressive negation, both extending the subjective politics that were dominant in the Sixties and critiquing their recuperation and subsumption into late capitalist institutions. Feminist zines and punk are often described by their producers as liberatory means to combat sexism, objectification, and passivity. This is seen as an intensely pleasurable and empowering process for the women who create DiY zines, music, and art. And yet, much of the imagery at work in these forms of cultural production is intentionally ugly, angry, and critical of mundane pleasures and practices. In this chapter I will explore this contradiction in the Nineties explosion of riot grrrl, queercore, and zines, and attempt to show it as part of a lineage that includes more contemporary DiY feminist and queer projects.

Chapter four, **Modern Primitive Play: CrimethInc's Folk Science**, explores the cultural dimension of a group best known and stereotyped as black bloc participants in Occupy and other movements. While recognizing its limits, this chapter attempts to understand the utopian mobilization of a pro-situationist sense of play by explaining CrimethInc's term "folk science" and its relation to their vision of spatial and subjective politics. In examining CrimethInc's writings and projects alongside the historical counterculture iconography of the hobo and of street games, we can explore a rich discursive toolbox that counters contemporary anti-youth, anti-spontaneity, anti-pleasure discourses.

The final chapter, **Impractical Politics: The Dialectics of Occupy**, argues that CrimethInc's and black bloc groups' participation in the Occupy movement should be seen in the

light of the epistemological and cultural dimensions explored in chapter four. Engaging with critical and sympathetic commentators of black bloc activity in the Occupy movement, this chapter makes the controversial argument that the tactics that are typically framed as violent and impractical can alternately be seen as effective forms of prefiguration and cognitive mapping.

In the face of pessimism and the dearth of widespread political organization, projects that keep alive utopian thought can be seen as important imaginative contributions to a more hopeful futurity. My analysis of DiY culture attends more carefully to its ludic, subversive and diagnostic dimensions than to its limitations as a pragmatic politics. In many ways DiY springs from and is similar to Hardt and Negri's flawed ecstatic mode in *Empire*. The realism at work in DiY modes does not always consciously take stock of the "remorseless realities" of our system, as Gopal Balakrishnan argues is necessary in order to develop strategy for the seizing of power and transformation of the system (148). When taken as a program, "anarchist immediacy" implies "a millenarian erasure of the distinction between the armed and unarmed, the powerful and the abjectly powerless," without any clear program other than the desire of the vagabond masses for a better life (147). However, when understood as "expressive negation," there is another kind of realism at work in these forms that provides a map of buried political desire and social energies. In the age of "no future," DiY practice allows for historical diagnoses and reframed political agendas (Jameson, "On the Power"). Other books have been and will be written to provide a comprehensive critique of the limits of DiY politics. This project is intended to be a rational, creative, and hopeful interpretation of oppositional culture. If, as Jameson asserts,

"Utopias... come to us as barely audible messages from a future that may never come into being," it is worthwhile to listen attentively for that future, and perhaps lavish it with a little excessive hope ("Politics of Utopia" 25).

Chapter One

"The hacienda must be built": DiY in the City

"Big city, it's a wishing well, Big city it's a living hell" sang the Berkeley ska punk band Operation Ivy, addressing the dialectics of postmodern urbanism with characteristic punk economy. In the face of gentrification, the city looms ever-larger even as the social relations that sustain it recede behind its smooth veneer. Excluded from the city's well-tended and guarded niches of order and wealth, the DiY punk forms a motley coalition with other marginalized urban inhabitants, and by existing, surviving, navigating, and sometimes disrupting everyday life, combats privatization and militarization. In the tradition of the *flâneur*, who is both enmeshed in and alienated from the city, the DiY urbanite maps the contradictions that bar the possibility of anarchism in one city while viewing the urban as an "incubator of revolutionary ideas, idealism, and movements" (Harvey, *Rebel Cities* xii). The role of the punk *flâneur* is to continually gauge the fluxes and currents of urban life and, when openings arise, to join the struggle to reclaim the city.

In this chapter, I look at the punk navigation of urban space as a mapping of and counter-discourse to closures and depoliticization in the city. I argue that this form of negation is itself utopian, in that it brings back politics as a category and allows an unlocking of political history. The yearning for political collective activity haunts and animates what the situationists call the "microclimates" of the city, thus mapping possible futures while still realizing that this is a period characterized by "history's breakdown, an ominous perpetual present in which no one knows what's coming... and indeed no one knows whether anything is coming at all" (Jameson,

"On the Power"). As a space of both breakdown and poten-
tial, the city doesn't exist as a monolith, it is geological: "you
cannot take three steps without encountering ghosts bearing
all the prestige of their legends" (Chtcheglov 1). These resid-
ual ghosts and buried histories become a model for utopian
spatiality. Against nostalgia, situationist Ivan Chtcheglov
defines utopian, anarchist "new urbanism" as a process of
praxis and futurity: "You'll never see the hacienda. It doesn't
exist. The hacienda must be built" (Chtcheglov 2).

Radical Spatial History in *Despite Everything*

Aaron Cometbus, one of the Bay Area's chief "punk anthro-
pologists," has become an overseer of this construction pro-
ject. He has been building his hacienda, the zine *Cometbus*,
for three decades. Disdaining the label "perzine," Cometbus
insists that the personal must be made coterminous with spa-
tially localized, punk, anti-capitalist collectivity. This spatial
impulse is evident in Cometbus's narrative of the historical
topology of University Avenue in an article "Berkeley Eyes on
University." Here he reconstructs the "sort of dreary and for-
gotten" street of University Avenue as a complex palimpsest
of personal, historical, and political memories. In his tribute
to the street, Aaron first maps the emotional touchstones
of his youth, citing the addresses representing particular
passional fields – 2070 becomes the best sex of his teenage
years, 2074 is his first leather jacket, 2054 is a band rehearsal
space, 2036 is a social space for shows and punk movies. These
personal memories are folded into the collective: shops and
institutions that had disappeared before he was born, acts of
sabotage and insurrection, the rise and fall of People's Park,
odd DiY landmarks and anecdotes. This topographic view of
University Ave. is set against the reductive and monolithic
plans of a Downtown Business Association which seeks to
clear out the rabble in order to construct a "rich homogenous

90's yuppie vision strip mall empire, where they own not only the buildings, they also take a cut of profits from each store".

At stake in this negotiation of space is a conscious desire to connect with radical history, a history, as in Greil Marcus's framing of situationist behavioral experiments, of "moments that seem to leave nothing behind, nothing but the mystery of spectral connections between people long separated by place and time, but somehow speaking the same language" (5). Aaron provides a sense of this continuity, memorializing the radical movements of Berkeley, his hometown, through mapping the history of political and underground papers. He narrates this history spatially, describing visits to the buildings where the papers were produced. Even in cases where these buildings no longer exist, as with *The Berkeley Citizen*, Aaron visits the site, eulogizing the paper as "an exciting cross between a local neighborhood paper and a muckraking freak rage". The paper itself was intensely local; it called for a car-free Telegraph Ave. and contained advertisements for small, now defunct, businesses. Aaron pays tribute to the rich history of the city by conjuring events and institutions mentioned in the paper: the uprisings at People's Park, the Provo "six point plan to revolutionize Berkeley," businesses such as Jabberwocky, Shakespeare and Co., the Steppenwolf, and the Blind Lemon. Many of the projects discussed in *The Berkeley Citizen* are now staples of DiY politics, such as the distribution of free food in the park, unofficially still called "Provo" park, after the Berkeley contingent of the Dutch counterculture anarchist group. Aaron understands himself and his own zine as part of this legacy, and dedicates himself to keeping radical history alive through alternative press. For him, the radical politics of today depends on these unofficial venues keeping subversive history alive. At another address on his underground paper walking tour, 1910 Sacramento St., Aaron visits the building of and describes the Sixties paper *Despite Everything*:

a searching for truth not available elsewhere, serious analysis, useful proposals for action, dry commentaries on local movements and reports of important political events such as pickets and protests.

The zine is lost to history; only 500 copies were made. But Aaron pays tribute to this obscure publication, naming his own published book after it (a book that achieved a circulation of at least twenty times that of its namesake). He does not let this smart, political, obscure effort disappear, but rather embeds it into the topography of the city and his own history. Implied in this gesture is the idea that zines are part of a linked discursive legacy of "biased," politicized counter-culture that counters the discourse of objective maturity in the mainstream press.

This logic is at work in Erick Lyle's/Iggy Scam's zine *Scam*. *Scam* parodied *The San Francisco Examiner*, a mainstream daily newspaper whose "objectivity," Scam believes, is merely a reflection of the opinions and declarations of the city's concentrated power elite. Combining activism and commentary, the zine took on "serious" projects of building solidarity among the urban poor and marginalized, while staying true to a punk ethos of unsentimental, darkly funny expressive negation. In one section, "Tenderloin Secret History," Lyle discusses his volunteer work with a needle exchange (a common DiY form of activism) that brings him to the most underworld and labyrinthine parts of the city. The job gives him access to intimate secrets about drug use and HIV, and he embraces this vilified neighborhood as a place of generative complexity, forming matter-of-fact alliances and relationships with junkies and prostitutes. His personal life is no less complicated and gritty, and he describes living with a girlfriend in a decrepit hotel haunted by historical mysteries.

The zine elegantly brings together all the themes we associate with urban modernity. Scam's punk slumming allows an intimate and gritty connection with all that is being disappeared from the rapidly gentrifying city, from the underclass to untidy, unflattering and unmonumental bits of local history. Even as he declares fidelity to the ephemeral and spontaneous episodes of city life, he carefully records and preserves these moments. He seeks out the fugitive history of the Tenderloin by searching for hidden tunnels beneath the city streets, and researching local history in the neighborhood library. In Lyle's narrative, the library comes to stand as a battlefield between official history and history from below. The section ends with Lyle trying to insert his own "secret history" into the library's policed collection of information by sneaking his zines onto the shelves. Like Aaron Cometbus, he sees punk culture as inextricable from political historical memory: "Piece by piece, I'm building a secret history collection" (25).

The 949 Market Street squat was a longstanding example of this spatial memory. For Lyle this squatted social center was a prefigurative vision of the utopian city, an attempt to learn what people would do with time and space if they had it, and to remind people of the power they already had. He sees San Francisco as a prime example of urban closure that is constantly threatened by popular protest, "a place where everyone had a dream about space that hinged on real estate" (112). Before 949 Market, young punks were reduced to doing art shows on bus stops and music shows in the Bart station. 949 Market Street created a permanent creative space. Lyle points to the irony of his position. While he was spending all his effort converting abandoned space into a creative prefiguration of the utopian city, he read articles in *The Chronicle* that depicted the space as barren and discussed ways of productively using it:

Should it be used for "Art"? For "Culture"? For "Affordable housing"? Or should it be just be turned into luxury condos? After all, the space was too big to be just sitting there UNUSED. It was hilarious: everyone in town was talking about our space and no one had a clue about the art, culture, and affordable housing inside of it that was already hidden in plain sight behind the shuttered door. (127)

Here, in this "abandoned" squat, what Henri Lefebvre called the lag between reality and potentiality is made explicit. DiY draws attention to the false issue of scarcity and austerity. Only out of the mouths of babes can we hear the clear truth: there is enough, they just won't let us have it.

Off the Male Map

DiY is a form of dowsing for repressed sociality. This impulse converges with Freud's spatially imagined "uncanny." The uncanny zone is frightening, unfamiliar, but also its opposite, the familiar, both that which is hidden, secreted, inscrutable, and that which emerges into the open. The uncanny repeats, it is a constant return where one is unconsciously compelled again and again to revisit the same area or object. Freud narrates this uncanny spatially, recollecting his own absent minded drift toward a red-light district in an unfamiliar town. He scurries away only to find himself drifting there again and again with "the helplessness we experience in certain dream states" (Freud 147). The experience is not of the other, but of the buried self, a repressed emotional impulse or longing comes to the surface as an uncanny affect. The *flâneur* wanders off the rational grid that elides these disturbing, uncanny spaces. She drifts into taboo zones — often those that are deemed repulsive, feminized or outlawed by social norms.

In the travel zine *Off the Map*, anarchist traveling kids

Tracy and Kika frame this form of psychogeography as a feminist spatial project. In Barcelona, a stop on their punk European tour, they approach some local counterculture women with a city map and ask them for advice on where to go. The women initiate them into a hidden world that includes a squatted social center, a cultural center for resistance community, a radical infoshop, a music center, the local co-op, and other counterculture zones:

> Soon the map was a constellation of carefully numbered red dots, and my journal was scrawled with the corresponding descriptions and metro directions... the city anew... if you want the cracks to widen, sometimes you have to show people where they are. (34)

At the "keimada" flat, a squat where the travelers end up staying, they continue their exploration of utopian spatialities, this time in a more intimate register. The interiors of the feminist squat come to represent an extension of this decoded map as the anti-tourists enjoy a house full of busy, comfortable women whose rhythms and habits are outside temporal and spatial norms, an easy collectivity where all act with mutual aid and without rules but where everyone does their part. A further extension of this counter-mapping is seen in the description of the women's bodies, which are comfortable and worn, and described in spatial terms as forts and dwellings:

> They hung and folded laundry, washed dishes, made crepes and coffee, all with bare and imperfectly gorgeous bodies. Lived in bodies, bodies claimed like favorite forts, bodies forgiven and broken in and used like a well loved pair of shoes. These bodies lived in nonchalant pleasure, outside the jurisdiction of magazine pages, housing the hearts of what I was certain must be *las mejores luchadores* in the city. (35)

The use of imagery such as forts, houses and jurisdiction suggests a DiY feminism in which the body itself becomes a psychogeographic experiment.

Savage Messiah: Punk Desire in the Ruins

In Laura Oldfield Ford's *Savage Messiah*, the stakes of DiY practice are at once highlighted and complicated. In an era of piecemeal forms of "regeneration," Ford implies that the process of narrating the city is more radical than reforming it. Describing her art as a form of "mapping the city along the contours of hidden narratives and oppositional currents," her fragmented drawings and prose fuse 19th century *flâneurie* with the aesthetics of Eighties punk.

Amidst encroaching privatized and bureaucratic urban zoning, Ford constructs a counterculture spatiality "haunted by traces and remnants of rave, anarcho punk scenes and hybrid subcultures at a time when all these incongruous urban regeneration schemes were happening" (xi). Her work is ingrained with the logic of the *flâneur*, an anti-hero who is fully shaped by and locked into a doomed struggle with the capitalist city. Benjamin's original conception of the *flâneur* is a product of late 19th century architectural Haussmannization characterized by urban homogenization, privatization, and spatial arrangements meant to prevent any urban revolt such as the building of barricades. Ford invents a spatial syntax to chart the progress of modernity while attending to the remaining preserves of underclass memory. By articulating the now-ness and spontaneity of counterculture youth to the defeated ruin-scape of the postindustrial city, Ford makes room for a messianic historical materialism against "historicism."

Benjamin distinguishes historicism from historical materialism, with the former term representing a view of history as "empty homogenous time" measured by incremental pro-

gress. Against this historicism, which can only reflect the perspective of the victors, *Jetztzeit* (now-time) allows for the articulation and resonance of historical revolutionary sensibilities, episodes, and periods. Through savage messianism – lyricism, black humor, and depiction of forlorn but intense romantic and social desire – Ford's "samizdat counter-history of the capital during the period of neoliberal domination" wrests culture from the powers that be, attributing any possible futurity to a history of revolt and struggle.

Although *Savage Messiah* has a different production history than the typical zine, and Ford's work appears in various venues, including private galleries and publicly funded institutions as well as social spaces, she calls her work a zine and articulates her work to the history of DiY punk aesthetics (xii). In one representative piece using punk styled cut and paste, a collage interfaces with text. The collage shows a tourist map of Millwall Park and a photo of an oppressive looking housing high-rise structure. Superimposed are strips of paper with punk-styled scrawls. On the opposite page, in typeface common to punk zines (mimicking that of a typewriter), is an impressionistic description of these privatized and dreary areas:

> Circle a gated enclave, a confusion of padlocks and blank windows. Infantile 80s pastiche, grotesqueries of riverside developments... across the water the skating Dome... proto gated communities, swaths of redundant computer terminals.

The strips of nihilist punk slogans – "NO ONE LIKES US", "we just didn't talk about it"— are the angry response to this barren landscape, a graffittied form of expressive negation. Although "no one likes us" reads as just another nihilist punk slogan, its resonance for British readers would more likely be a football chant with ambiguous political undertones. Such

subcultures as working class whites, whose class-based anger mingles with racist resentment, confound simple political interpretations of slumming. This issue was reflected in Michael Collins comparison of journalists who villainized rowdy football fans to Baudelaireian *flâneurs* – class blind intruders on working class turf. Ford's work, then, doesn't make a claim for a clear inclusion of punk subculture in an official left lineage of political art. Instead, she captures that which is left out of historical framings: the microclimates of underclass everyday life that remain in the interstices of the smooth postmodern city.

This ethos explains the commitment to non-linear juxtapositions and palimpsestual layerings of harsh and bucolic tones. In one passage, a hazy, smoke-filled room in a loud, junky squat seamlessly fades into a pastoral woodland scene:

> punk rock blasting from Reef House on the Samuda estate. Cockney Rejects, window rattling volume. Sitting down to smoke amidst the detritus of a light blocked living room. Round the headland, looping now, blocks emerging from woodland, hazy in violet light. Filtered through amethyst lens. Mase and Greenwich shimmering across the river. ...Balmy summer night. Drinking in the beer garden beneath Alfeges, lilac shadows, orange street glow. Honeysuckle, jasmine and rose... Fire of London.

These shifts in tone belie the stereotype of punk as a simplistic recourse to immaturity and anger, showing, instead, punk as a way of salvaging emotional nuance from abjection. Here, seeming punk nihilism is shown to be a kind of revolutionary romanticism of reclaimed spaces with "no future" but the past.

Savage Messiah is almost a synergistic project, where all media and forms of expression are experienced as spatial tonalities. Rather than quote the poetry of Paul Verlaine and

Arthur Rimbaud, Ford traces the spaces they visited: "Their rooms lurk behind a façade of peeling stucco and violent eruptions of buddleia." She sees them as "proto flaneurs, already walking through the ruins of the future... intoxicated by glyphs and a heady confection of gunpowder, tobacco and rotting wood..." As Kristen Ross chronicles, Rimbaud's coordinates and spatially based syntax generate from the Paris Commune, a moment of social and spatial rupture. Ford's depiction of the poets' squalid and elevated romance, and its comparison with contemporary punk love allows for a cognitive mapping of urban social and sexual desire. The question, tellingly, is not how or with whom to have sex, but where to do it:

> We kiss on the steps, he wants me to go back to his, I want
> to break in here. In the alleyway, or during another undoing
> encounter, climb the fence.

Implicitly referencing Benjamin's *Arcades Project*, Ford weaves in his meditations on heroic degradation, desire amidst the ruins where "poets find the refuse of society on their street and derive their heroic subject from this very refuse."

Savage Messiah is less concerned with the loss of nature than the loss of the struggle for nature. The scrubland posts in Whipps Cross are memorialized as "the last output of the road protests." In the face of "an intensification of Tory road building... the destruction of houses and the ousting of entire communities," these transient squattings and protests allow for "radicalizing moments." The memory of struggle is paired with the recrudescence of nature, indicating that a return to nature is not pre-lapsarian, but post-post-lapsarian, after the revolution:

> the rituals of the green wood, shimmering red dot locations
> in this trapped corner of Leyton flats... I am hurtling into a

flashpoint of dissolution, 5am delirious in the morning dew.
I am enchanted by violent blue eyes, the ace of spades on a
pale hand, desire illuminating his face, in the first pink shreds
of light.

This form of psychogeography that merges with ecstatic
nature conjures the mystic notion of "ley lines," where a
feminized logic is attributed to natural configurations out-
side of the patriarchal grid of civilization. But here again, this
feminine element is a form of negation, a point of purchase
from the gentrifying grid, rather than a pre-historic edenic
and forever-lost past. Ford invokes the anti-road protests
as gnostic and "preromantic," guided by Hermes, a "liminal
god, inhabiting the interstices." This insurrectionary zone
belongs to outcasts, especially the feminized, "gypsies sui-
cides, witches, outlaws." She sees a utopian kernel in the
disintegrating city, sliding into forest and dust, uncovering
repressed desires. This nature does not represent authentic-
ity, but rather a refusal of preconceived and approved notions
of progress, a defiance of inevitability.

The figure of the precariat somehow seems to inhabit both
the foreground and the background of this anomic landscape.
In another collage we see a close-up of disconsolate eyes, a
strange bird toy or cake floating over a highway, and super-
imposed we see a sketch of a young service worker looking
up into nothing. Here, youthful sexuality is seen as poor
compensation for real collectivity, an "atavistic ritual" in the
face of flimsy "New Labor gestures." The depiction flickers
between reification and utopia as we catch glimpses of "the
green man," who connects the alienated service worker to
an originary expulsion from the commons, "the gating and
enclosure of our land, the robbing of our public space." In
Savage Messiah, enclosure of the commons is not a punctual
incident in the past; it is a continual repetition that is still

being contested in mutated forms, "the devilment of sabotage, the euphoria of riots and the thrill of wildcat strikes…"

These flaring moments of resistance, "eyes flashing with the thrill of an encounter," resonate with Walter Benjamin's guiding sense of messianic temporality as a means to "blast open the continuum of history." This "now-time" contests a hierarchical historicism that erases past struggles and measures out time as a linear trajectory of progress — "homogenous empty time." In *Savage Messiah*, we see punk culture in its evocative density providing a counter-discourse to a historicism that defends existent power structures in the name of progress. Here, in often-muted and ambiguous tones, expressive negation counters a rhetoric of necessity and austerity with a messianic youth-oriented sensibility that holds out hope for a post-capitalist, redemptive futurity.

DiY Outposts

The compressed temporality of the now-time helps us imagine precapitalist festival as an inspiration for a future sociality. The festival is an edenic moment of imagined unity, a reconciliation of humanity and nature, of community, and individual vitality. Following this logic, the DiY group CrimethInc imagines the temporary autonomous zones created by insurrections and anarchist projects as a form of spatialized radical memory, a form of "outpost" during a long decline in capitalism, providing "some memory of freedom, some rumor of resistance" ("Beneath"). Although these temporary autonomous zones, in some senses, are byproducts of what Rebecca Solnit calls "disaster capitalism," here, DiY spatial practice stands as a ghostly terrain of collective action, inspiring and readying itself for an arduous and largely uncharted journey toward a transformation to come.

Chapter Two

A Rising Tide Sinks All Boats: Bay Area DiY

The California Bay Area's DiY scene is arguably the capital of punk modernity. The end of the line in the westward course of empire, the Bay Area serves as a frontier of reform and revolution, manifest destiny and manifestos, elite culture and counterculture, labor revolt and labor containment, cosmopolitanism and provincialism. DiY culture offers youthful struggle against the "maturity" of austerity and the acceptance of the status quo, revealing and denaturalizing the impasses in the supposedly "left coast city." With the Disneyfication and gentrification of the Bay Area, it's no longer possible to rest content with the production of a radical culture which itself can be the stimulus for further gentrification. Rather, DiY becomes a means of mapping depoliticization and the necessary "failures" of the counterculture while still aiming to create a vibrant, prefigurative radical scene.

From The Sixties to the Seventies:
Bay Area Counterculture's turn to Expressive Negation

The story told by Bay Area DiY has its lineage in Sixties counterculture, and thus can be tied to the Bay Area's central role in the "world historic event" of global 1960s uprisings, especially the anarchist, countercultural dimensions of the New Left. This period gave rise to alternate, future-oriented forms of temporality and spatiality emerging from what Christopher Connery calls the "radical co-presence" of the Sixties ("World Sixties" 87). The idea of a "worlded" Sixties that includes Western counterculture allows for a vision of Sixties time as a "stand against given time, against capitalist time, against abstract time" ("World Sixties" 106). This alter-

nate temporality, what Rob Wilson points to as the "bohemian, mongrel, socialist, queer and left leaning energies" of San Francisco, permeates the logic and form of DiY, allowing for a picaresque style in which rebellion and resistance still have expressive power even in the face of totalizing forms of abstract time, privatization, and gentrification (584).

At the same time as DiY continues the lineage of Sixties counterculture it must also contend with what Fredric Jameson calls the "universal abandon," of the Sixties in which promises of abundance and freedom were recuperated by deterritorializing forms of finance capital ("Periodizing"). This is the logic that influences the transition of San Francisco from "Baghdad by the Bay," a strong labor town with somewhat politically unified blue collar workers and thriving economics, to "Balkans by the Bay," a fragmented urban regime focused on services, tourism, and hospitality (DeLeon 13). The context for this shift is the "Manhattanization" of San Francisco — the rapid constructions of high rises and expansion of downtown — requiring a razing of "blight," which often translated to destroying working class neighborhoods in favor of high-rise and tourist constructions (DeLeon 54). These facilitated the emergence of a new urban regime that served as a center of advanced corporate services in management, finance, law, and communication, leading to income and occupational polarization between high tech, information jobs and low wage service and building jobs supporting residential and commercial gentrification. The workers needed for this new context are educated and communicative but lack economic and social power which has become dispersed and thinned due to the drop in unionization rates, the lack of service unions, the cooptation of unions, and the concentration of power in an overwhelmingly pro-growth, business oriented urban regime. For this powerful elite, the overall vision of the city is to provide "the physical and social

means of capitalist production and accumulation within a global division of labor", with an expanded commercial downtown area that would prove a global hub (DeLeon 41).

During the abundant period of the Sixties these changes gave rise to a flowering counterculture, critical of conformity and American involvement in foreign wars but confident that a new utopian culture could be built out of the ruins of the old. Many of these forms of counterculture had their birth in the Bay Area: beatniks and peaceniks, diggers and squatters, acid tests and happenings, free speech and free stores, Underground News and Underground comix. These developed alongside political movements involving Black Nationalism, Maoism, Native American activism, and anti-imperial wars. These radical energies, however, were muted or eclipsed by the depoliticization, financial recession, and high rental prices of the post-Sixties.

The rise of punk, then, was a simultaneous recognition and repression of affinity with Sixties counterculture projects. It is in this spirit that Bay Area zinester Aaron Cometbus develops a wry historiography that is both enthusiastic and skeptical in order to recount the history of counterculture small businesses on Berkeley's Telegraph Avenue. He shows Moe's Books, the beloved used bookstore created by counterculture eccentric Moe Moskowitz in the Sixties, to be both a monument to Sixties anarchism and a fossilized and profit-driven institution that ignores punk subcultural production. Aaron does not reject the reified remnants of the Sixties, as was the first impulse of Seventies punks (see *Punk* magazine), rather, he investigates its contradictions. When the now settled and wealthy former owner of Telegraph Ave. new age store Shambala rejects his request for an interview with the curt phrase "I don't care about the past," Cometbus claims the radical Bay Area past as his own DiY legacy:

For the rest of us, the only thing we'll ever own, especially on
the Ave. is our stories. Our collective identity and our stake in
the culture we're part of and trying to maintain. Why make
it hard for the rest of us to feel part of that? Why be angry at
me for a desire to tie our stories together and share them?
("Loneliness" 26)

The punk aesthetic is born from an age of recession, privat-
ization, soaring housing prices and few employment alter-
natives. Yet these forms of lack are also sources of critical
wealth, denied to the now-comfortable, middle-aged hippie
storeowners. This evokes Madeline Lane-McKinley's argu-
ment that the cultural imagination of the "global nineties"
had a vampiric and recuperative relationship to the Sixties,
enacting a "process of undoing" (*After the 'Post-60s'*).

Cometbus interprets hippie criticism of punk negation as
a lack of access to understanding, a willful blindness:

I thought that's the problem with hippies. They can't live
with themselves when the lights are out. No wonder they're
so angry at us, able to accept the darkness and even celebrate
it. It would be funny, if only they hadn't taken all the rent
controlled apartments for themselves. All of us Berkeley kids
had to move away in order to find a place to live. Now here I
was back in my hometown for the holidays with no one to light
the candles with. ("Loneliness" 26)

Cometbus describes a community that has been driven out of
their homeland, the counterculture mecca of Berkeley, whose
colorful, tourist-friendly shops mask the closure of oppor-
tunities for simple living and time for creative production,
something that came so easily to the generation before. He
invokes his exilic Jewish heritage, "the Loneliness of the Elec-
tric Menorah," as he spends Hanukah without these friends.

Cometbus speaks with the wisdom and distance of a historian in his often neutral and generous account of the rise and fall of Telegraph Ave. In the Seventies and early Eighties the nature of the transition from Sixties euphoria to expressive negation was less clear. The Bay Area's first major punk club, the Mabuhay Gardens, served as both bridge to and break from the Sixties. Tentatively at first, then wholeheartedly, owner and Filipino activist, Ness Aquino, allowed Dirk Dirkson to book punk shows at his club. His will to survive as a club owner was indicative of his tenacity. When other businesses in Filipino town, besieged by redeveloping forces, caved, he had fought to save the International Hotel, a symbol of collective energies of marginalized workers, students, and the emerging third world movement at San Francisco State University against downtown expansion and business interests (Habal 21).

The nature of this emergent subculture rising from the ruins of Sixties counterculture was unclear. The bands Dirksen booked at the Mab. beginning in 1977 were diverse, ranging from the artier band the Nuns who overlapped with new wave and Goth, to Crime, a loud, pared down rock-based group who dressed up as cops, to the Avengers, affected by visual and sonic British band styles such as having spiked hair and paint splattered clothing, to The Offs who were influenced by reggae. This scene signified a liminal zone between Sixties and Seventies politics, imbricated with political events such as the 1979 White Night Riots, an uprising in response to the light sentence of Dan White, who murdered progressive leaders Harvey Milk and George Moscone. After this event, punk bands such as the Offs and the Blowdryers played benefits to raise bail money for people arrested in the course of the riots (Belsito 105).

Punk's rejection of the Sixties was aimed at subverting reification and commodified forms of older countercultures. As

James Stark notes, Bill Graham had come to control the San Francisco music scene, manufacturing the next "hot thing", while punk wanted to destroy the next big thing (5). Says Jeff Rafael from the band The Nuns: "Punk was about people expressing themselves, being in control of their lives, and not having some corporation deciding what they needed" (Stark 5). The Mab originated as an autochthonous and diverse place for anyone who didn't fit into earlier and homogenized forms of counterculture. At the time, many clubs didn't want live music. Says publisher of *Punk Globe* Ginger Coyote:

> ...it was easier for record companies to put out Donna Summer type canned music, disco, love to love you baby kind of stuff. Club owners felt that as long as they could get people to pay a door charge to dance, then why should they have to deal with the expense of presenting live entertainment." And the places that did have live bands were hippie bands. (Stark 10)

The hippie scene, *Search and Destroy* editor V. Vale argues, had become avatars of the status quo: "These were very conservative people masquerading as radicals with wild clothes, wild hairdos, platform shoes, yet these were essentially boring people with old fashioned sexist, materialist values" (Stark 13).

The Mab. provided a fresh and unpredictable mix, if only for the year of '77, argued Jeff Olener of the Nuns:

> ...it was fabulous because it was like your own private scene you had created. It was like wonderful, you know. It was artists, writers, photographers filmmakers, musicians all different cool people mixed up. There weren't very many punk bands there because there really weren't any. So they kind of mixed in regular rock in the club as it got popular. Then different people tried to take it over, to make money on it, to cash in. (Stark 14)

This was a fresh wave of creativity before another wave of reification, the dialectic we will see throughout punk. Says Nuns member Jeff Raphael, "At that time you could kind of judge people by the way they looked. There was that kind of niche thing. There was us and them. It was that kind of alienation from the straight world that brought people together" (Stark 16). Here, even the word punk was not set in stone. Says V. Vale:

> To reduce a comprehensive cultural revolt to punk rock is a typical technique (reductionism, oversimplification is historically used by power structure media to belittle any kind of threatening change). Here society's machinery of cooptation again showed its infinite capacity to assimilate all rebellious spirit and impulses. (Stark 29)

Along with this wave of punk came a voluntary and enjoyable poverty, with people on welfare stuffing small apartments. Before making more contact with the British scene, the Bay Area had a unique and specific do-it-yourself approach to aesthetics and politics. The Dils, for instance, had songs which exuded crude, emotional class critique as in the song "I Hate the Rich", and direct engagement with California politics in their lyrics such as the Briggs Initiative and Proposition 13. In an interview, Tony Dil critiques the reductive view of British punks toward SF, who accuse Americans of being distant from class politics:

> I live day to day. I live a hand to mouth existence. It's really funny when I read English papers: 'well these American guys really don't know what it's about do they?' (Vale 33)

Dil's understanding of politics is outside formal organization and he is uninterested in defending his radicalism in other

terms. Instead, he values punk as an escape route from dead end lives in small towns. He describes his high school friends in Carlsbad as emotionally dead at 21, "They don't have any scope. They don't have any perspective. A lot of them have started to buy or are trying to raise money to buy their own homes" (Vale 33).

The Dead Kennedys took this Bay Area reaction to the Sixties to a new level. Front man Jello Biafra owed much to Sixties direct action groups like the yippies, and performed similar stunts, such as his 1979 guerrilla mayoral campaign, which included vacuuming leaves off of opponent Diane Feinstein's front lawn and launching a platform demanding that business men wear clown suits, along with serious demands to legalize squatting in abandoned buildings and to require police officers to be elected to their positions. However, despite Biafra's teenage identification as a hippie, the band's aesthetic was based on a reaction to and critique of Sixties reification. As Madeline Lane-McKinley argues, punk formed a counter-discourse by articulating "the negation of the 1960s as a refutation of countercultural recuperation" (*After the 'Post-6os'*).

The song "California Uber Alles" does this by taking on the voice of California's "liberal" governor, Jerry Brown, and illustrating that hippie sentiments have been harnessed to emerging centers of power. The lyrics paint a dystopian new-age dictatorship of flower power, 100% natural "zen fascist control," mandatory jogging, smiling and mellowing out. This is the "conquest of cool" in which hipster police will bring deviants to flower bedecked concentration camps. This ethos, as Joshua Clover has argued, is crystallized in the final episode of *Mad Men* where new-Age self absorption facilitates the rebirth of Sixties struggle "as raw material for the corporation's soft-power victory over '6os revolution" ("Our Mad Worlds").

Growing up, Jello Biafra was profoundly influenced by hippie culture, wore his hair long and identified with the Sixties legacy, and yet when he came to the Bay Area he recognized that this anti-hippie gesture was the break needed to create a new counterculture that was open ended and future-oriented. This was not out of a rejection of the Sixties, but out of the sense of coming too late and needing something new:

> There's a whole generation of people like me who have never been acknowledged—people who are between 'baby boomers' and 'Generation X-ers.' Even though we were very young, my generation felt the real impact of the '60s. When I was graduating from high school in '76 and many of my closest, wildest friends had dropped out, one who didn't remarked, 'Look at all this shit! Everybody's getting so straight now. WE MISSED THE SIXTIES.'(iii)

With the closure of the Sixties, punk brought a new figure to the streets of San Francisco, less naïve and optimistic and thus attuned to contradiction and impasse in ways that were no longer available to the hippie aesthetic. In this context, expressive negation maps the political core of a waning Sixties social movement while refusing the piecemeal gains that are doled out in its wake.

Radical Homelessness: Squatting the Bay Area

In this post-Sixties time of economic crisis and closure, the Bay Area punk found herself sliding up and down the spectrum from voluntary poverty to involuntary homelessness in the face of a transforming and gentrifying city. The background of this precarity can be traced to 1949 when the federal local urban renewal program's powers of eminent domain, as well as subsidies for buying and clearing land, led to an irreversible reconstruction of urban space. This began

with the Golden Gateway renewal project and expanded south with the creation of the Yerba Buena Center. This inexorable process of downtown expansion gave rise to new forms of privatization and exclusion of the poor but also to new forms of social movements, tenants' organizations, and many other anti-expansion groups (Hartman 303). Symptomatic of a general trend in what Mike Davis calls the "planet of slums," homelessness became the fulcrum of SF politics and the limit case of liberal discourse due to the city's housing politics. San Francisco came to have among the highest housing costs in the country. In 1996, it was necessary to make approximately $100,000 annually in order to comfortably rent a two-bedroom apartment (Hartman 326). San Francisco's ostensibly "living wage" of $10 an hour was not sufficient to provide a worker with basic needs. Low-income housing had become scarce, with absurd statistics such as 5,700 people applying for fifty-five affordable housing units. Much of low-income housing had been demolished to make way for redevelopment. Where traditional forms of anti-gentrification activism had fallen short, some DiY forms filled the void, with groups such as The Mission Yuppie Eradication Project advocating the vandalism of yuppie vehicles and establishments. Nevertheless by the mid-Nineties much of the Mission was well gentrified.

This urban transition coincided with a period in which some Bay Area punks began to drop out more fully, squatting at "The Vats," an abandoned brewery first occupied by the band MDC, and at Polytechnic High, an abandoned high school near Haight Ashbury. It was with the Hotel Owners Laundry Company (HOLC) squat that an explicitly anarchist, politicized punk squatting scene arose, becoming a home base to events such as Rock Against Reagan, and started positive projects such as prohibiting drugs, and requiring tenants to put in their time providing food and keeping the squat intact.

With visits from politicized European squatters networks, HOLC announced the Bay Area's entry into a new phase of global anarchism. This phase was connected to events that showed a dawning explicit politics, as in 1984 when punks descended on the San Francisco Democratic convention with musical accompaniment by bands such as MDC and the Dicks. In the same year, the punk-organized "war chest tour," which foreshadowed the anti-corporate demonstrations that would break through in the 1999 "Battle of Seattle", and which inaugurated the US version of black bloc tactics.

Ben Sizemore of the band Econochrist describes punk's political intervention into the apolitical ennui of the Eighties as such:

> There were riots, there were earthquakes. The East Bay hills were on fire. There were blackouts. The first gulf war and the Rodney King trial. There were huge fucking protests in San Francisco with people burning cop cars down by the transbay terminal. It was a crazy time. Being a young idealistic punker from Arkansas with real leftist political views, I thought it was great. The revolution was just around the corner, man. And I was gonna be there!

A 1989 three-day gathering in Dolores Park crystallized these politics as anarchist. This culminated with a "day of rage" where black bloc tactics were used and a building was occupied under the black flag (Belsito 362). This explicit politics was underlain by squatting culture which served as a resistance to privatization, lack of housing, and, poverty. This shows the compatibility of expressive negation and a prefigurative construction of a utopian, communal, everyday life with what Madeline Lane-McKinley sees as "the production of social space, unbound to the logic of territory" (*After the 'Post-6os'*).

The 25th Hour: Erick Lyle and DiY temporality

Bay Area zinester Erick Lyle sees DiY as a place to experiment with temporality. In the punk, excessive, "25th hour", urban progress can be temporarily transcended and reimagined. His zine *Scam* operates as advocacy, news, and counterculture aesthetic practice all at once. The zine functions as a mock newspaper that directly critiques the lack of public space and humane treatment of the homeless through recording transformations, interrogating leaders, and depicting the down and out residents of areas such as the Mission and the Tenderloin. By conveying the "news" through the DiY aesthetic of expressive negation, Lyle's writings chart the conflicting temporalities of Bay Area forms of "progress" and contestation, objectivity and subjectivity.

In 2008, Lyle amassed his writings in a book *On the Lower Frequencies: A Secret History of the City*, which is now one of the most comprehensive and pithily written documents on gentrification in San Francisco. His articles, stories, and anecdotes are focused on his own and other marginal figures' everyday lives as they attempt to subvert and elude gentrification. In his collection he treats his zine *Scam* as a primary document that provides an alternate history of Nineties anti-gentrification, anti-war, squatting, and alternative press movements in San Francisco. The zine's aesthetic is in the mode of bricolage, an attempt to reassemble urban detritus as a means to imagine utopian space and activity:

> It's something that I come to again and again in the book,
> these sort of lost utopian moments, where we'll have some
> squat in SF for three months where we're serving free food
> and having these amazing shows and actually living the life we
> want on earth for these ephemeral brief moments, and I think
> that writing and literature, whether it's fiction or nonfiction,
> creates a space where those ideas that are sometimes too

fragile to survive in the light of day can live on dormant, like a virus, in print, waiting for their moment to come back. (*Maximum Rocknroll*)

Lyle's instinct is to combat the threat of "group amnesia" of working class and counterculture memory in the face of an aggressively homogenizing modernity. Against forgetting, Lyle conjures preindustrial forms of storytelling and spatial practice, creating what Bernd Huppauf refers to as "spaces of the vernacular" (85). Huppauf points to Ernst Bloch's theory of the vernacular as one that can account for the historical trajectory toward a ratiocinated abstract space while accounting for local place, the *heimat*, not as an organic site of identity politics and reactionary nostalgia, but as a place produced by modernity. The vernacular points to the nonsimultaneity of time and thus frees the imagination to dislodge events from an ill-fated historical future. This vernacular temporality is Lyle's "25th hour": imagination, anticipatory modes of thinking, the space of childhood. The vernacular takes the form of negation to designate a "not yet" potentiality in the "hollow spaces" outside of capitalist productivity and the totalizing forms of modernity. In the face of symmetrical and rationalized spaces of the modern city, the vernacular supplies crooked and jerry-rigged constructions that spring up in the crevices of seemingly smooth, impermeable façades.

This vernacular form relates to Walter Benjamin's understanding of the temporality of the storyteller — for which storytelling is a form of constant presentness and endurance, countering the frantic pace of modernity. DiY logic and Benjamin's understanding of storytelling share a sustained reference to preindustrial craft culture in contrast to an elevated notion of art. Storytelling sets itself against modernity and progress, advancing a languorous sense of temporality and functioning as a palimpsestic, repetitive, collective endeavor.

Storytelling also foregrounds a sympathy for "rascals and crooks," navigating the picaresque mode and yet at the same time has a sense of "righteousness." Here, the ethical dimension is collective, as righteousness will shift from character to character rather than resting in individual wisdom. In zines, this oral, collective, craft-oriented form is evoked in order to provide a generic, as well as political, outside to the hierarchical logic of "progress."

Lyle's episodic, picaresque stories of the Mission District are never fully containable by clock time, bourgeois time, ratiocinated time, reminding us of the cyclical time in the pre-capitalist orientation of storytelling. In "A Rising Tide that Sinks all Boats" this utopian temporality is manifest as a "never ending back and forth" of daily life that is depicted as the source of creativity and beauty that undercuts the tragic telos of the narrative:

> On San Carlos Street there was a daily sweet and sad procession, a never ending back and forth, that we could watch from our steps. There was the sound of men pushing fruit bar carts up the alley, clanging their bells, calling out and there was that tense, menacing no-sound sound of cops cruising slowly the wrong way down the alley. The girl down the street that I had a crush on would walk by, short sleeves in the Mission sun, smiling sleepily on her way to morning coffee at 1:00 pm, and Eddie the drug dealer would walk the other way, looking exhausted, sagging against a palm tree with gang tags carved into its weathered trunk. (5)

Far from utopia, this "working class street" is "a place with problems that money wouldn't solve." But Lyle sees it in terms of its possibility, a street that is "for now, asleep and dreaming."

In this flawed community there are few unambiguously

happy endings, not for the bookbinder who refuses to call the cops on a homeless man who loiters outside his shop, instead, teaching him bookbinding and giving him jobs. The narrative does not resolve heroically, with the homeless man reformed, but rather is the story of the two men settling into a flawed but working relationship, in which the homeless man's crack habit makes him a somewhat shabby but serviceable worker. In this way, these vignettes escape narrative closure and what the situationists call "dead time." Instead, they subscribe to the excessive, cyclical temporality of the DiY picaresque:

> But I think that's why I always liked that story. It didn't have a feel-good happy ending, but they were still trying to work it out. This back and forth, this trying to work it out seemed like it would go on, 25 hours a day, forever. (6)

With gentrification, this picaresque life is threatened. A cyclical temporality of messy contingent solidarity is confronted by a financially backed temporality of progress, of "cleaning up the Mission," justified by the notion that this rising tide will "lift all boats."

Lyle's character Jacque is the embodiment of the dream, a landlord who hopes to ride the rising tide of the Mission and better his lot. Rather than a figure of power, Jacque is shown to be a pawn in the losing game of gentrification and bubble logic, whose precipitous rise and tragic fall is countered by the enduring humor and simplicity of the unambitious punks and homeless in the neighborhood. In his quest to better himself, Jacque attempts to evict Jimmy, Lyle's fictionalized roommate, using the Ellis Act, which allows landlords to evict tenants as long as they refrain from re-renting the property for ten years. In order to "be where the action is" Jacque moves into his property in the Mission, yet his individualist dream is no match for the collective resources of the commu-

nity. As a counterpoint to Jacque, Jimmy, the character who is evicted, is depicted as an unambitious folk hero, a "self-employed scavenger" who generously shares his findings with his friends (6-7). Jacque on the other hand, is portrayed as one who wants to raise only himself up, in order to hold on to his dignity and his upwardly mobile wife. As in the San Francisco based novel *McTeague*, and so many other tragedies set in the Bay Area, this speculative dream foreshadows a tragic downfall:

> Whatever he thought, our house was now something else to him, a symbol of some brighter, well-heeled future. It was a chance for a henpecked plumber to finally hit it big, to be where the action is, to not be a small time landlord anymore. And all they would have to do would be to get rid of US. (7)

In the end all of Jacque's plans come to naught as the wave of gentrification in the Mission is shown to be just a blip in the economy, and his properties are devalued. In this picaresque reversal, the would-be tyrannical landlord is outwitted by the DiY figures whose lack of ambition allows them to evade the tragic logic of speculation altogether. Jacque's undoing is finalized by Jorge, who represents a grotesque personification of the uncontainable power of the underclass, the spectral 25th hour risen from the grave.

> Jorge was the homeless guy who slept under our stairs, but to say Jorge was just some homeless guy would be to say Shakespeare was just some writer. Jorge reinvented the role. With his trench coat, his thick, greasy beard, and his wild mass of jet black hair, Jorge was more of an ominous presence, a force – not so much a harbinger of doom, but a reminder that you were doomed, a feeling, like a hangover, that had always been part of San Carlos street and always would be. (8)

This destructive force drives Jacque to extremes; he destroys his own property by taking out the garden, incorrectly thinking that it will deter Jorge from sleeping there. Jacque's doomed attempt to move up in the world turns him into a maddened tragic hero, driven to tapping his tenants' phones and to wildly accuse them of hosting orgies and committing felonies in a state of "almost Kurtz-like collapse" (12).

The story ends with a contrast between Jacque's tragic view of the city based on individualist, aspirant values, and the stirrings of the inexorable and protean force of the underclass:

> Jacque stood at the top of the steps looking out across San Carlos Street, a street with problems money couldn't fix. How could he have known what would happen next, that within a year, the real estate boom would bust, the stock market would flounder and lots would stand vacant all over town? ... I don't know but from the look on his face, I could tell Jacque had figured it all out, all at once. His high paid lawyer got in his SUV and sped away. The younger man opened the car door for Claire and they drove away too. The house was finally all his. And somewhere, Jorge was stirring for his morning rounds (12).

Lyle's picaresque mode allows a conception of youthful delinking triumphant over the mature forces gentrification, discursively interrupting seemingly intransigent and incontestable forms of urban development. This again disrupts the rhetoric of maturity and points to the imbrication of this ideology with "progress" as a whole.

In *Secret History*, Hunts Donuts is figured as another site of vernacular spatial practice, operating in a utopian timelessness set against the linear, ratiocinated temporality of capitalist development and bourgeois aspiration. At the same time that Lyle figures Hunts as a refuge for punk slumming, he also shows the shop's role in relation to the

development of gentrification. The donut shop is a staple hang-out for punks, embodying the DiY gravitation toward vernacular, marginal, degraded spaces that are seen as bastions of underclass tenacity, inventiveness, and singularity in the face of a homogenizing gentrification. Lyle depicts Hunts Donuts as a working class space that spans the transition in San Francisco from industrial modernity to postindustrial Manhattanization. But with its post-Fordist degradation and criminalization it becomes a barometer of tension between gentrifying and grassroots forces: "How you felt about Hunts donuts might reveal your position on the changing Mission district." To some who enjoy grit and funky independence it is felicitously "undomesticated" (85). On the other hand, for law enforcement and others it is seen entirely as "the focal point of undesirable elements in the Mission," a site of panhandling, drug dealing, illicit transactions, and loitering.

For Lyle, Hunts represents a historical continuum of underclass energies. Prewar it was "a hardscrabble point of entry for Irish, German and Jewish immigrants, a sort of lower east side for SF that included many socialists and anarchists." In the Seventies, Hunts becomes a liminal space in the battle between white "civic boosterism" and Latino grassroots collectivity, galvanized by the trial and defense of Los Siete De La Raza, a group of Latino men who were falsely accused of murder. This movement developed into neighborhood activism that extended to programs designed on the model of Black Panther projects such as clinics and free breakfasts, giving rise to the notion of the Mission as a cohesive Latino area.

Lyle uses the history of Hunts to narrate the political history of the Mission district at length. This approach is a means of creating DiY history from below and a way of framing DiY autonomous projects as acts of solidarity with the autonomous projects of other marginalized groups through

what Lane-McKinley calls a "counter-logistical cartography." This attachment to Hunts and the specific aesthetics of punks in the Mission is seen to reflect this intense locality. Lyle evokes the downbeat, rickety tone of this deindustrializing area as an aesthetic that permeates punk music, describing a box set of 45s by punks about the Mission that featured splices of Latino culture. Punk life intersects with other abjected groups in the squalor of Hunts, a vernacular space through which generations of marginal forms pass. Lyle's descriptions of Bay Area life offer a counterculture counter-history from below that contrasts those narratives that champion a sterilized city, purged of its underclass, in the name of development, profit, and progress.

Cruel Optimism of the Will in Bay Area Punk Production

By 1986 punk was not just a battle cry, it was a scene that required institutions like show spaces and record labels. In this context we see the rise of the Gilman Street project, an all-ages punk musical venue in Berkeley. The club opened soon after the closing of Mabuhay Gardens and The Farm, two important punk venues in the area. You could join as a member by paying $2 per year, and membership came with rights to participate in decision making. The rules included: no drugs, alcohol, violence, misogyny, homophobia or racism, and no major label bands were permitted to perform there. Says Zarah of her introduction to Gilman at 14 years old:

> Gilman was dirty, it was small, but it was impressive because of how many people were there. I was meeting lot of people right away (people my age). I was in love with the place form the first time I saw it, even though it was, you know, gross. (Edge 236)

For Eighties teenage Bay Area punks, Gilman was a semi-utopia: a creative, social space where they could come-of-

age in ways not permitted in family and school institutions.

Alexander Kluge calls this kind of DiY institution a "counterpublic sphere," a place that redefines spatial, territorial, and geopolitical parameters, reflecting new transnational boundaries while remaining subject to the constraints and logic of dominant post-Fordist forms of production. In this counterpublic sphere, the Gilman punk could experiment with residual temporalities, such as DiY artisanal production, without ever leaving the home of modernity – the sphere of universal, fungible commodity production. In this elastic sphere, people like Robert Eggplant, creator and primary writer of *Absolutely Zippo*, could find a viable way of life that was social and at times ecstatically political:

> When I first came to Gilman (yes shortly after I came to punk)
> I was faced with something that I never encountered in my
> previous subculture groups, (that being rap and metal). There
> was more in the atmosphere than music. (Yes even more than
> liquor and sex). It was politics. (Edge 113)

Eggplant describes himself as a somewhat lost soul until attendance at the "new world" of Gilman made him into a punk convert, speaking to his hunger for openness and community, totally immersing him in its culture and social scene.

Gilman materializes and spatializes this feeling of community, fortifying a subculture that could once only be described as an impulse or a feeling with a layer of solidity and permanence. The club has the appearance of spontaneity and haphazardness, but it represents years of concrete work that were put into finding, funding, and creating the space. The space supersedes the temporary squats and show spaces that preceded it. Most of the organizers developed their skills by organizing illegal shows, gradually building up to getting a permitted, legal establishment. The group that had been

organizing underground shows collaborated with *Maximum Rocknroll* to find a location and to acquire the appropriate funding and permits (Edge 73). After lengthy attempts to get the city to approve, Gilman Street was born as a self-regulating institution. This permanence is an important asset to the scene and yet with every step away from the fleeting and ephemeral Gilman approaches punk's dreaded nemeses: hierarchy, bureaucracy, reification.

Despite these threats, Gilman served as a punk haven and base from which to build a radical community. In the Eighties Gilman provided a home base for anti-racist punks to fight off skinheads. In this moment, racist skinheads were a strong, insidious presence in Northern California. Because of overlapping musical tastes, the Gilman staff had to drive off Nazis from hardcore shows and in some instances the punks of Gilman rallied to fight Nazis at racist demonstrations. In the Nineties Gilman became a center for punk protest against the Gulf War and the Rodney King decision. For Ben Sizemore of the Bay Area anti-capitalist band Econochrist these politics were inextricable from hardcore aesthetics. Radical politics were a bodily and totalizing power:

> Bands like those got my heart pumping and my spine tingling. I could feel the chords hit me in the gut. I felt like they were singing directly to me. The music moved me, but it was more than music, it was something else, a more powerful feeling and it ran deep. (Edge 157)

These were the politics of musical ecstasy and at the same time the politics of the mundane everyday, quotidian survival and mutual aid:

> Hell, people I've met at Gilman have become some of my closest friends. I've met people at Gilman who hooked me

up with work, housing, and have just helped me out with
my problems. More importantly they've helped me realize
I'm not alone and that there are alternatives to this fucking
competitive, dog eat dog, oppressive, materialistic, earth
raping, dominant culture that we find ourselves in. (Edge 157)

In this milieu mutual aid extended from attending and sup-
porting Gilman shows to all realms of the everyday – dump-
ster diving, parties, and communal living.

Gilman's everyday politics provided a social and political
world for young punks stranded in an atomized world where,
as in Karl Marx's prognosis, "all that is solid melts into air."
But with the anchorage of Gilman as an institution came
what Econochrist calls "the same damn old circle game":

we scream fight the system's schemes / but we still work
for the machine / so safe in our social clique/time to part
this sea of shit

With the materialization of Gilman as an institution comes a
creeping entrepreneurial ethic, an urge to codify and market
the punk convergence of art and life. As one of the many who
came of age at Gilman, Mike Stand lived this ambivalence.
He was a high school kid in Berkeley in 1986, at the birth of
Gilman, and clung to its "all-ages" ethos, which defied the
strange age segregation of the suburbs. Before he went to the
club, Mike hadn't met anyone between the ages of eighteen
and thirty-five. This age segregation belies the myth that a
wholesome suburban life is the proper path to maturity. Sub-
urban life actually prevented teenagers from meeting young
adults, carefully cordoning them off from any adults who
hadn't already settled into the suburban norm. Slipping into
the role of Gilman's coordinator and manager, Mike matured
quickly, but this led to his tacit disavowal of the youth-

ful spontaneity that is the core of the punk aesthetic. Mike framed himself as the resident "pragmatist" who learned skills that would help him in the business world. He kept Gilman afloat, calling for membership fees and making it fiscally sustainable, but, as Erick Lyle points out in his account of the punk role in the San Francisco Mission District's gentrification, contrary to the boosterish slogans of urban development, a rising tide does not lift all boats.

Chris Appelgreen also "matured" quickly in the nurturing countersphere of Gilman, inheriting Lookout! Records from Larry Livermore at the age of twenty-three. Drawn to punk for its social space more than its musical qualities, he describes coming from a small town and immediately becoming absorbed in the club and Lookout!

> I couldn't really differentiate what made punk rock better than say Depeche Mode or other mainstream bands that were on the radio. Then I started seeing this humanity and personality and connection you just couldn't have if you were a fan of Tina Turner or Bruce Springsteen, for instance, also the band members were people my age. I felt really empowered. (Edge 152)

He notes that this was a first step in taking himself more seriously and led to his quick ascension to heading Lookout! At the same time he recognizes that his involvement with Lookout! complicates his relationship to Gilman:

> It was also a difficult place to come into things from, since I had to maintain somewhat of a business relationship with the people in the bands on the label, people who I was friends with. It was different than I think most people's experiences were with Gilman. (Edge 153-154)

The permanence of Gilman and Appelgreen's position in it came at the price of a certain degree of specialization and alienation.

The paradox of the punk entrepreneur or manager is not a stark problem of choice. Rather, it's a necessary consequence of what Guy Debord called the culture industry's "rigged game" in which there is no possible autonomy from entrenched systems of production and private property. The punk anti-corporate myth faced new challenges in the late Eighties when this independence moved from the realm of the aesthetic to the realm of commerce. Independent labels were never as pure as their mythic status. For instance, the Bay Area band Dead Kennedys has been held up as a pure signifier of this form of delinking, but in 1980 the Dead Kennedys signed to IRS records which had a distribution deal with the major label A and M, the third largest label in the US (O'Connor 3). It was not the Dead Kennedys who rejected this label, but A and M who dismissed the Dead Kennedys because of their offensive name, precipitating the advent of the Dead Kennedys' label, Alternative Tentacles. It was only well into the Eighties that punks began to distribute and produce most of their own records. This coincided with punk becoming more niche oriented. For example, in 1980 the Dead Kennedys could sell 150,000 copies of the album *Fresh Fruit for Rotting Vegetables*, but by the mid-Eighties it was rarely heard of for even the most popular punk band to sell 40,000 albums (O'Connor 3).

The widely published punk music zine *Maximum Rocknroll* was central to what can be called punk's "economic turn." At the same time the zine was widely distributed, its editors and writers, especially central editor Tim Yohannan, were deeply committed to notions of authenticity and independence (O'Connor 4). *Maximum Rocknroll* is at the hub of many of the debates about the management and goals of Bay Area punk

institutions. It began in the 1980s and went on to become a central site of punk scene interaction nationally and internationally, facilitating growth through its ever-expanding letters column and involvement in many areas of Bay Area punk music, venues, and labels. It was also an ideological hub of punk, featuring debates and manifestos about the meaning, politics, and goals of punk music along with interviews with bands and global scene reports. Although the zine was profitable, it donated these profits to DiY projects such as Gilman. *Maximum Rocknroll* was passionately committed to the ethos of autonomy and would only carry ads and review records from independent labels. This was important, because *Maximum Rocknroll* was a central source of information about bands.

Maximum Rocknroll functioned as a global hub that launched punk culture into small towns and other countries, serving as what Andy Asp of the Oakland punk band The Pattern calls the "internet of its times," allowing punks to connect to Mexico City, Croatia, and other global punk communities. *Maximum Rocknroll*'s power and influence, along with the strong opinions about politics and culture in its pages, made it a global center, but also launched debates about whether the zine's centrality served to standardize punk. Tim Yo was seen by many to be morally rigid and authoritarian, a complaint voiced by Tim Tonooka:

> He was deeply concerned that kids might think incorrect thoughts unless they were provided with carefully selected correct info... Because left to their own those people might come to the wrong conclusions. The mentality is elitist and condescending. (Boulware 188)

To the annoyance of many, Tim Yo served as the superego in the Bay Area quest for punk authenticity. He attempted to

run *Maximum Rocknroll* as a prefigurative anti-capitalist pro-ject. It was produced in the house where the staff lived and everyone worked for free. Even though the zine passionately defended hardcore music, in private Yohannan expressed less interest in the music than the hope that it would provide youth with collective revolutionary identity.

DiY's incursion into the economic everyday required great organization and collaboration. *Maximum Rocknroll*'s power-ful place in the Bay Area punk scene was based on reciproc-ity with other institutions, such as the distributor Mordam records, which was dependent on the business brought in through *Maximum Rocknroll*'s wide distribution and therefore also upon the involvement of Tim Yohannan and other *Maxi-mum Rocknroll* editors. Because of Mordam's scale and ambig-uous place as an autonomous/profit-driven punk institution, the label makes clear the tensions between punk aspirations and material realities. Mordam attempted to remain autono-mous by refusing to sell through major labels or to distribute any zine that accepted major label advertising (O'Connor 37). Paradoxically, they were largely able to maintain this inde-pendence because of the great success and commercialization of the Bay Area band Green Day. When Green Day signed onto a major label, their earlier releases became popular, eventually selling over a million copies through Mordam.

While Mordam grew and expanded due to this boom, the intransigent nature of real estate in the Bay Area simultane-ously curtailed this expansion. With the dot com boom, real estate prices soared and Mordam could no longer afford their large warehouse once their lease expired (O'Connor 57). These vicissitudes cannot be explained through a reductive binary that pits authenticity against selling out. Rather, the context of a post-Fordist economy must be taken into account. This can be seen in the class position of DiY entrepreneurs, which reflected the emerging occupational structure of the US, the

shift to services, and the importance of what Pierre Bourdieu calls "cultural capital." Punk culture participants, musicians and workers are emblematic of a new kind of precarity. They often come from middle class homes, but do not inherit stability from their parents. In some senses, then, these institutions present a limit case of neoliberal entrepreneurialism.

These experimental forms of DiY institutions and collectivities are impassioned but equivocal responses to a period dominated by precarity and impasse. Lauren Berlant argues that the fantasy of the good life characterized by economic success has been disrupted by contemporary crisis and the "fraying" of fantasies such as meritocracy, upward mobility, job security, intimacy, and political and social equality. In place of these hopes, individuals and groups form optimistic stances in relation to jerry-rigged, DiY, forms of habituation and precarious public spheres, acting as "an intimate public of subjects who circulate scenarios of economic and intimate contingency" (Berlant 3). Impasse is for Berlant both a temporal crisis and opportunity:

> a stretch of time in which one moves around with a sense that the world is at once intensely present and enigmatic, such that the activity of living demands both a wandering absorptive awareness and a hypervigilance that collects material that might help to clarify things, maintain one's sea legs, and coordinate the standard melodramatic desires. (Berlant 4)

Punk's teetering and inquisitive dialectical position between active resistance and passive style embodies this experience of crisis.

In this precarious and crisis-ridden era, punk arguably ceases to be a genre, transforming into a more nebulous modality. Fredric Jameson sees the postmodern as a post-genre moment marked by pastiche and the death of referen-

tiality. However, punk's aesthetic can be seen as the flip side of pastiche. It has no pretension to originality, but rather takes up the detritus of meaning and referentiality, cutting and pasting these shards to negate their original meanings in an intentional way, a process formulated by Guy Debord as *détournement*. As Dick Hebdige argues, punk's cut n' paste aesthetic can allow a critical incursion "through perturbation and deformation to disrupt and reorganize meaning" (Hebdige 106). This counters what Benjamin Noys sees as an "affirmationist" trend in contemporary literary and theoretical formations, which imagine an autonomous aesthetic "site of creativity and play detached from the forms of capitalist economy and value" ("Recirculation").

Lauren Berlant's notion of cruel optimism can help with the investigation of punk's role in spheres outside of the purview of subcultural theory. Berlant's formation of "cruel optimism" develops the critique of affirmationism and positive representation, by bringing it into the field of everyday life, extending an analysis of *détournement* and hacking, as analyzed by McKenzie Wark, into the arena of jerry-rigged counterpublic spheres. The optimism in these moments of the "crisis ordinary" can be seen in the vibrancy of these social experiments, but the "cruelty" of this situation is that the attachment it allows is to a problematic and precarious object or situation (Berlant 24).

Within this "crisis ordinary," DiY projects like Mordam, *Maximum Rocknroll*, Lookout! Records and Fat Wreck Chords optimistically create new forms of social and spatial practice. However, because of the "cruel" circumstances of these formations, these desires end in what I want to call, following Stacy Thompson, productive failure, with "failure" operating as a troubled category (Thompson 147). This is echoed in a lyric from Echonochrist's song "Bled Dry": "What you call success I call failure." Jameson points to failure or impasse as

a possible means to cognitive mapping in which "a narrative of defeat" can cause "the whole architectonic of postmodern global space to rise up in ghostly profile behind itself, as some ultimate dialectical barrier or invisible limit" ("Cognitive Mapping" 352-353). The trajectory of Bay Area label Lookout!, headed by Larry Livermore and later Chris Appelgreen, maps this contradictory form of failure. One of the early utopian stances that the label took was that it initially did not sign contracts with its bands, which allowed bands to come and go as they pleased without tying them down to requirements to tour or sell a quota. They also gave bands a significantly higher percentage of profits: 60% as opposed to the average of 12-15% in commercial labels. In 1998 Livermore sold Lookout! to Appelgreen, who changed these policies to be more commercial. As Stacy Thompson points out, this transformation was not simply a selling out, but a productive failure that highlights larger structural contradictions and the impossibility of true independence from the system.

Here "failure" is a complex term. Punk productions "fail" in selling on a scale that would register in the commercial sphere. The DiY approach doesn't pose any significant economic threat to the music industry, representing only a tiny sector of the indie market. This failure, however, is a success in that it allows these labels to avoid being controlled by economic logic. A second productive failure is the inability of punk to supply a living income to musicians, condemning them to supplement their income by working in the commercial sphere. This, however, is "an inverted form of success," prohibiting music from becoming merely a means to an economic end. In zines such as *Maximum Rocknroll* the volunteer aspect is philosophically central; each issue notes that all the work is donated and all proceeds are invested in nonprofit projects. The smaller scale of Lookout! is a "partial failure that renders visible the problem inherent in

punk's attempt to free itself from the sphere of commodity exchange" (Thompson 151). Punk records cannot fully escape the need to make capital available and to purchase the means of music production, and bands themselves must do some alienated labor, such as touring and repeating sets. However the work done is considered less alienated than other forms and much of it is unwaged. The implicit logic of the ongoing passionate argument about selling out in the punk world is an interpretation of winning as the true loss. *Maximum Rocknroll* becomes the arbiter of this failure, refusing to review, interview, write articles, or allow advertisements by bands that appear on major labels or that appear on indie labels but are distributed by major labels or their affiliates. In the face of the impossibility of creating a totally new community, punk's idealistic failures "preserve the possibility of a potential social organization that did not yet exist." Unable to overturn the current system it "rendered its logic visible and suspect" (Thompson 156).

This "failure," is often framed as "the death of punk," but can be seen as rather the mark of punk's deepened incursion into the everyday, in a period that coincides with the Bay Area replacing New York as the capital of DiY. The post-Seventies phase of DiY culture has become self-reflexive, bringing its own foundations and discursive assumptions into question and developing a more sophisticated critique of the culture industry as "a skilled predator on the prowl for fresh young subcultures" (Clark 232). Punks saw that the general speed-up in absorption of stylistic innovation in modernity meant that grassroots culture could become commercialized in a matter of months. An aesthetically fragmented punk could partially evade this cooptation of what Dylan Clark calls "market democracy" (Clark 233). This phase of punk is already post-punk in that early punk relied on shocking a confused mainstream. As Fredric Jameson often notes, the postmodern

mainstream becomes more and more adaptive to experimental forms. Because of this, late punk's strategy had to be an evasion of spectacle and a deepened critical anarchism. This phase draws on the stripped down ideology of earlier punk and its dedication to experience in place of symbolic encounters. Punks refer to the scene in which they hang out rather than calling themselves punk, and evade concrete descriptions of themselves but rather participate in political projects such as anti-corporate movements, Earth First!, and Reclaim the Streets (Clark 234). In this way, "punk faked its own death," decentralizing and losing its markings, becoming instead "a loose assemblage of guerrilla militias" (Clark 234). As it enters this phase, the punk aesthetic becomes inextricable from anarchism. Jeff Ferrell notes that while some participants may draw their practice from an overt understanding of anarchism,

> this isn't a necessary prerequisite, appropriately enough for an orientation founded on direct action, many seem to find their anarchist politics right there in the experience of everyday life. (Ferrell 88)

In a moment where, as the situationists argue, the everyday is fully colonized by capitalist logic, it is also, conversely, permeated by the political in all its mundane forms.

Bay Area institutions such as 924 Gilman and Lookout! point to what John Charles Goshert refers to as the "pervasive economic and social attitude in the Bay Area punk scene", with Gilman providing a political meeting space, local collectivity, and creativity (Goshert 98). San Francisco becomes the capital of punk modernity as these institutions become the models for other labels, bands, and venues throughout the country. With the rise of punk as an economic and institutional force and the gathering of political and other commu-

nities around these institutions, punk had the opportunity to become more diverse. So in the early Nineties, Gilman hosted diverse genres such as performance art, funk, jazz, heavy metal, and country alongside the predominant punk shows. The explicit anarchism and collective running of Gilman allowed for this collaboration, and freed punk from rigid aesthetic requirements. Instead, it was understood that punk's survival was becoming dependent on "constant mutation and unrecognizability" (Goshert 99).

Larry Livermore describes this phenomenon in the zine *Absolutely Zippo*, in a discussion of the play of a high school student (although she is not named, it turns out that it's Miranda July who went on to be a well-known performance artist and film maker) at Gilman as embodying the spirit of punk by avoiding punk clichés and avoiding reification, rather stressing what he sees as innovation and independence. His description of July gets at a core punk value of refusing punk clichés:

> I also have to tell you that even though I've never seen her at a show and she doesn't have any piercings or tattoos (not that I saw, anyway) she's more punk than 95 percent of you reading this mag. Why? Because she does something, she takes her vision and makes it your reality, she takes imagination and shapes it into something we all must contend with... Because she's not waiting for the next edition of the punk handbook to tell her the appropriate ways to rebel and be creative. (Livermore 35)

This constant evolution of punk as a logic rather than a set of encoded practices is central to its capacity for expressive negation as subcultures struggle against increasingly adaptive forms of capitalist logic.

This understanding of the relationship of subcultural music to a transformed everyday helps to explain how punk music can be simultaneously popular and difficult. Fantasies of punk authenticity are belied by the fact that markets themselves are parasitic on grassroots taste. This push and pull of resistance and complicity forms the core contradiction of the punk approach to everyday life. These marginal phenomena: DiY musical, entrepreneurial, and everyday production thus navigate success and failure, high and low, inside and outside, rebellion from and absorption in everyday life. Because of the complexity, diversity and centrality of the contemporary city, the everyday merges with high, experimental art, "the avant-garde project of purposefully mismatching perception and the taken-for granted in order to release perspectives from the fetish of common sense tends to find a contemporary realization in the daily culture of the metropolis" (Chambers). This relationship to capitalist temporality, ratiocination and ambition in the ghostly "25th hour" of a counterculture temporality does not constitute a clear political program or a full utopian transformation. Instead, Bay Area DiY is a flexible form of utopian negation that necessarily fails, and in doing so succeeds in mapping the impasses that must be known in order to one day be surmounted.

Chapter Three:

Lineages of Expressive Negation in Feminist Punk and Queercore

Feminist zines and punk are at once an expression and a critique of pleasure. Ecstasy is found in destructive, ugly, and angry imagery that precludes mundane pleasures and practices. Feminist and queer punk counter-institutions force the continual provocation of punk, as the subcultural milieu is necessarily haunted by complicity and reification, patriarchy, and heteronormativity. At the same time that punk feminism nurtures emergent intimacy and collectivity between girls, it is itself haunted by its own spectacular recuperation by the media and inclusion in an all-pervasive commodified culture.

Punk feminism intervenes in a widespread recuperation of second wave feminism by a new stage of capitalist logic. Feminist punk and queercore come in the wake of what Nancy Fraser argues is a dismantled and partial feminism, wrenched from its original context as a radical challenge to patriarchy, distinct from but embedded in the widespread social movements of the long Sixties. In the Seventies, Fraser argues, feminists were able to formulate a "ramified and systematic" critique of economic, cultural and political forms of gender injustice ("Feminism" 99). This unified attack on androcentric oppression was unraveled by the assault of an emergent "post-Fordist, 'disorganized,' transnational" form of capitalism. Feminism arguably provided a necessary role in "the new spirit of capitalism" as it was used to legitimize structural transformations that were antithetical to women's liberation ("Feminism" 88). Not only do new forms of the economic feminization of labor exploit supposedly liberated working women but, as Nina Power explains in her Marcusean analysis of the ideological use of feminist "repressive desublima-

tion," hawkish justifications of war in the Middle East are launched in the name of feminist liberation.

In the wake of these failures and occlusions of second wave feminism, punk negation becomes the response for a new generation of young women who are not able to envision a financially secure future as either worker or homemaker. They have witnessed their mothers' domestic chores slightly diminished by the dishwasher, washing machine, microwave and yet these freedoms have not benefited them. The new quasi-feminist economy is one in which women are integrated into the labor force more frequently but not in equal conditions to men. The modern woman contributes disproportionately to the market, helping stoke growth in profits and national income overall, and yet is personally less well off, often no longer supported by men or the state. She is told that it is her individualism or lack of nurturing instincts that has corrupted feminism and undermined female prosperity. A spectacular appearance of women's independence and autonomy masks the disintegration of social and legal framings for women and families' support. The same forces that mark the ability of women to divorce and explore their own sexual desires also point to the dismantling of social obligations to women and the avoidance of new commitments (Thistle 147).

In this regime, women are pushed into low-wage jobs and the informal economy while family is no longer seen as integral to the reproduction of labor but a luxury. Women's access to culture is not necessarily an antidote to this condition, as the feminization of labor has corresponded to the rise of a society saturated by culture. This impasse marks a moment that Jameson calls "the cultural turn," that is the penetration by the market of all realms of culture which were previously autonomous. In this context, even expressions of rage and non-conformism can be packaged and sold. In the face of this

conundrum, feminist punk takes on the explosive form of expressive negation.

The Politics of Feminist Punk Style

In a moment where postmodern pleasure has become a form of compensation for or masking of the evisceration of social infrastructure, feminist punk and queercore develop a dialectical embrace and critique of pleasure that adds up to the historicization of pleasure's impasse. To this end, Fredric Jameson historicizes Roland Barthes' postmodern notion of pleasure as the emergence of the material, libidinal body against bourgeois discipline and narrow "culinary" spectacular pleasures. In a post-Sixties moment that has seen a wave of what Herbert Marcuse calls repressive desublimation, exemplified by the simultaneous liberation and commodification of sexuality, pleasure cannot be given a simple, encompassing positive or negative valence but can only be viewed allegorically. Chris Chitty frames this desublimation as the "reification of sexual desire" and exposes this phenomenon as an internalization of the postmodern erasure of an outside to capitalism or an authentic "nature." This presents desire and pleasure as delimited by their social context even as alternative sexualities and gender identities achieve a form of liberation. Further, as Kathi Weeks argues, our post-Fordist, post-Taylorist forms of production rely on augmenting and manipulating emotion and pleasure: "Profits in the service-and-knowledge-based economy depend increasingly on simultaneously activating and controlling, on releasing and harnessing, the creative, communicative, affective, and emotional capacities of workers" (56).

Thus, local political struggles for particular forms of pleasure are worth fighting for, but at the same time these must be taken "as the figure for utopia in general, or the systematic transformation of society as a whole" (Jameson, "Pleasure"

73). Pleasure as expressive negation can serve as a gesture toward unimaginable possibilities, the opening of a void – "a moment of silence, a question without answer... a breach without reconciliation, where the world is forced to question itself" ("Pleasure" 73). Feminist punk points toward this allegorical status by simultaneously affirming alternative possibilities for pleasure and articulating the limits and occlusions of these possibilities.

From its inception, punk gave women the ability to refuse patriarchal and capitalist modes of expression, even if they were not provided with positive alternatives. This was done by estranging female roles as objects of the male gaze through parody or refusal. Punk was an early example of a musical genre in which women were not typically limited to the chanteuse role and instead often played instruments or sang in a dissonant scream or shriek. Punk rarely had a positive political platform and instead operated as a form of nihilistic refusal, opposing "mainstream politics, propriety, and taste" (Leblanc 36). Clothes and style were always at the center of this form of expression and women often were central shapers of style. An inaugural moment of punk was a shocking bondage clothing line at the shop Sex. Most narrations of punk begin with the Sex Pistols and the fact that Malcolm McLaren owned the store, but the style itself was created by a woman, Vivienne Westwood. Her clothes were at once revealing, overtly sexual, but also designed "not to titillate, but to provoke... not to entice but to horrify" (Leblanc 37). The music that opened the door to women was shocking and dissonant, "a cacophony of near deafening but politically passionate, punk rock" (Leblanc 47). Thus, here the destruction of pleasure is the means to critical negation that is in itself pleasurable and creative.

The occlusion of female experience leads to negative strategies of representation. Punk figures do not advance a posi-

tive politics but rather represent a semiotic "politics of style." Early punk performers such as Patti Smith, Debbie Harry, Poison Ivy, Tina Weymouth, Chrissie Hynde, and Polystyrene operated parodically to map the limited possibilities of female self-representation. In the first wave of punk, the styles for women ranged from androgynous figures such as Mo Tucker, to hypersexual performers like Debbie Harry, and hyperstylized women like Jennifer Miro (Leblanc 35). Punk female musicians were likely to play an instrument or develop a persona that was ugly or aggressive. Patti Smith's explosive mode of performance points to the negative, sublime pleasure in feminist DiY. She was not a singer but a poet, an ecstatic in search of "naked performance" (McNeil and McCain 159). She sought to be blown apart, to be imbued in ritual. For Smith, poetry is seduction: "having power over people, making them love you, an expansion of consciousness that becomes a collective experience" (McNeil and McCain 162).

Punk's negative aesthetic is one of sublime fear; often punks are the objects of moral panic. In the Eighties a wave of talk shows and sensational news depicted punk as a dangerous subversion. The "Back in Control training center" advised parents to "depunk" subcultural teens by removing posters, albums and clothes, and changing their style. 83% of psychiatric institutions approved the treatment of punk style even if the teen did not display any other subversive behaviors (Leblanc 58). At the extremes of this panic, Leblanc tells of one girl who spent more than ten months in psychiatric hospitals solely for being a punk. The publicity surrounding the punk scare drew in disaffected youth even if they did not have access to punk scenes. Feminist zinester Mimi Nguyen describes discovering punk through TV "Punksploitation" (shows such as *Dragnet* with plots that villainized and distorted punk culture):

Here I was, Asian with slanted eyes, feeling visually out of sync, so seeing punks on TV being visually out of sync struck a chord. I felt, wow they're in control of how freaky they look. Looking other is something that's always been imposed on me, now I can turn that around. And of course, there was always some editorial about punk being dangerous and offensive to "good people." I had lots of revenge driven fantasies of offending "good people." After all, the same people who blew up our mail box in Minnesota went to church on Sundays. (Vale, *Zines* 85)

The villainization of punk along with its rejection of positive representation gave voice and openings to the uncategorizable anger of young women. Thus, while DiY is often associated with a kind of affirmationist anarchist spirit, its creation of a space for negation was often the most compelling aspect for women and girls for whom the fantasy of positive-identification had been elusive. The implied view of feminism here supports, Ben Noys' argument that the rethinking, rather than the rejection, of negativity is crucial to evaluate and persist in contestatory politics today ("Recirculation of Negativity").

Riot Grrrl's Anti-Pleasure Dissertation

In the late Eighties and Nineties a new wave of feminist punks emerged. The university town of Olympia became a center of activity where K Records became an important independent label. In Washington the Dischord label also gained traction. Riot grrrl emerged out of this context of independent production and distribution. In Washington riot grrrl began in 1988 when Sharon Cheslow, Cynthia Connelly, Amy Pickering, and Lydia Ely organized discussions on punk and gender related issues noting that the supposedly alternative punk community did not question a gendered division of labor, with men in bands and women working behind the scenes in distros or

as the writers of fanzines. In Olympia the beginning can be marked by Tobi Vail's punk feminist zine *Jigsaw* and Sonia Dresch's queer zine *Chainsaw*. In 1989 Bikini Kill formed with members Kathleen Hanna, Billy Karren, Toby Vail, and Kathi Wilcox and this was soon followed with the formation of the popular band Bratmobile. Shows began to include bands with female members such as Bikini Kill, Mecca Normal, Heaven's to Betsy, Lois Mafeo and 7 Year Bitch (Leblanc 47).

Riot grrrl directly negated traditional male-centered forms of pleasure, in which, as Suzy Corrigan points out, "women are brought to life in the eye of male beholders" (147). This contradictory semiotics of riot grrrl self-presentation stemmed from the material conditions of these women. Many of the initial riot grrrls, including Kathleen Hanna of Bikini Kill, were art students who survived by stripping or sex work. By navigating the contradiction of using sex work money for feminist creativity, they developed an ironic and flexible view of female objectification. Inspired by a previous generation of feminist performance artists such as Karen Finlay and Annie Sprinkle, they negotiated sexual performance and transgression. "Kinderwhore" fashion at once embodied a critique of rape and a sex positive response to conservative "parent culture"; it operated as both a critique of porn and critique of censorship (Corrigan 159). This flexibility often led to adaptation of queer, camp style. Suzy Corrigan notes the influence of filmmaker John Waters, whose shock cinema challenged social mores through extreme scatological and grotesque humor (163). In riot grrrl lyrics, liberation lies in "the seedy underbelly of the carnival" where sixteen year-old girls give carnies head "for free rides and hits of pot" (Bikini Kill "Carnival").

Bikini Kill's song "Anti-pleasure Dissertation" captures the complexity of taking ownership of a sexuality that is necessarily lurid and degraded. The lyrics are comprised of a long invective against a boyfriend, indicating that the speaker knows his pleasure in sex is seeing her as a conquest. She accuses him of using her for power and status in a game that is still played between men. The song posits that punk rock is losing its critical potential when this kind of mainstream sexism persists:

> did you tell them everything I said... Did you get a good
> laugh?... Tell me... /Was it good?/Was it good for you?/Did you
> win that race?/Did you score that point?/Are you so fucking
> cool fucking cool now?/Go tell yr fucking friends/What I
> saw and how I felt/ How punk fucking rock my pussy is now!
> (Bikini Kill, "Anti-Pleasure Dissertation")

The song continues as a relentless, hopeless rant about the lack of possibility of female pleasure, the inevitability of passivity and objectification. Then, a twist at the end:

> I don't care I don't care/I don't care I don't care/Honey baby
> baby this I know.../Maybe I like you/Maybe I do (Bikini Kill,
> "Anti-Pleasure Dissertation")

A temporary solution lies in negating the speaker's own thesis and positing a possible different outcome.

The pleasure here is in negation of male sexism but also negation of the idea that this sexism is interminable, thus instilling a sense of flexibility where male punk objectification of women has ossified the subculture. The victory here is negative, giving women the power of refusing the arbitrary judgments of the male gaze, as in Bratmobile's song "Affection Training":

See Mr. Whatever describe himself/It's frightening to feel worthless/In the eyes of worthlessness/My fear has nowhere left to go/Impossible- I can't get me no no.../All the girls are fighting over/The dumbest boys who run this town/I watch myself get watched like TV/But I'd rather run you down. ("Affection Training")

The politics of pleasure in DiY feminism cannot go far beyond the possibilities, the "maybes," of "Anti-Pleasure Dissertation." Rather, pleasure is usually expressed as a sublime moment of anger or negation. Women's traditional role in music is the passive, pretty fangirl. The riot grrrl instead chooses ugly imagery, often seeing herself in violent opposition to the now-canonical and reified star system of male-dominated punk:

I will become the murderer if there's only two choices. I am mass murdering all rock stars in my head... (Hanna, *My Life*)

She demands the end of patriarchal forms of cool which now represent the absorption of her own subculture into spectacular, commodified, and specialized forms of cultural production. The song "Thurston Hearts The Who," critiques the kind of fan knowledge that creates hierarchy in the punk scene simply by repeating the refrain: "Thurston hearts The Who. How about you?" The riot grrrl does not want to kneel at the feet of rock god Thurston Moore nor listen to him talk about the bands he likes. And she doesn't quite want to be him. But, for her, the male punk is the only means to approximate agency:

I wanna be your Thurston Moore/wrestle on the bedroom floor/always leave me wanting more/throw away those old records. (Sleater-Kinney, "I Wanna Be Your Joey Ramone")

With the male rock-star as the bearer of symbolic power in what Gayle Rubin calls "a phallic culture," the riot grrrl appropriates his role through expressive negation, which "carries the meaning of the difference between the 'exchanger' and 'exchanged,' gift and giver" (192). In this context, potential girl love and lesbianism can only be depicted negatively through the simultaneous presence and absence of the male rock star.

The Media Kills the Message

In 1992 the riot grrrl movement attained mainstream coverage and soon there was a media frenzy with articles in many publications including *Off Our Backs*, *Newsweek*, *New York Times*, *Washington Post*, *Rolling Stone*, *Spin*, *LA Times* and *Playboy*. This was seen as a form of cooptation where queer bands and threatening aspects of the movement were downplayed:

> We have been written about a lot by big magazines who have never talked to us or seen our shows. They write about us authoritatively, as if they understand us better than we understand our own ideas, tactics and significance. They largely miss the point of everything about us because they have no idea what our context is/has been. (*Jigsaw*)

Such fear of recuperation by the media became a common trope in riot grrrl lyrics. Often notions of community were set against the anonymous, isolating realm of fame. The theme of many songs was selling out, getting famous, trading in friends for employees and sycophants:

> Who is gonna put in our tape-deck?/Who is gonna carry the bass-amp?/Who is gonna buy us a van?/It could be you/It will come true… oh. ("Hamster Baby")

With fame, this temptation to sell out becomes a central impasse and the source of the movement's implosion. Thus in Bratmobile's song "90s Nomad" we see a lament for not having "made it" while at the same time a more popular band is harshly criticized:

> 1-2-3 it's been going great guns this fiscal year but I still haven't made it / anywhere I go I see your face and I hear your name all over the place... Now you're crying about too many fans and trying to tell me that it wasn't / your plan, oh well. I can never feel sorry for you, in times like this, it's / always you.

These sort of internecine critiques and policing of boundaries can also be seen as indicators of the way that riot grrrl was symptomatic of a larger problem in DiY culture, its insularity and inability to connect to a larger community. Further, as Michelle Cruz Gonzales argues, female punk bands that didn't identify as riot grrrl, like her Chicana punk-band Spitboy, were in danger of being erased from even these narrow forms of publicity and historiography (Skolnik).

As the movement's reluctant spokesperson, Kathleen Hanna struggled with this impasse. Hanna already had witnessed the beginning of her friend Kurt Cobain's downfall, as Nirvana's wild popularity gradually eroded the band's sense of connection and purpose. Bikini Kill attempted to stave off this reification by keeping the band small scale, talking to clubs personally when booking shows, and switching instruments to avoid specialization. Hanna, who had experienced sexual abuse and whose lyrics often address this topic, compares media exploitation of riot grrrl to an abusive father who molests his daughter under the table "while above the table, society just sees two smiling people" (Juno 83). However, despite this harsh critique of the media, a force that alienates Hanna from a community defined by its independence, she

remained ambivalent about this fame: "getting trapped in little circles of shame and blame isn't going to create serious analysis of the situation, it also isn't going to make corporations or co-optation go away" (Juno 87).

This impasse is partially overcome by forming independent means of distribution, marking a significant step toward a movement of DiY feminism from the realm of circumscribed forms of culture to more generalized everyday life practices. In answer to the question "why riot?" the riot grrrl manifesto calls for the seizing of the means of production and distribution as a way to transform daily life as a whole:

> BECAUSE we must take over the means of production in order to create our own meanings.
> BECAUSE viewing our work as being connected to our girlfriends-politics-real lives is essential if we are gonna figure out how we are doing impacts, reflects, perpetuates, or DISRUPTS the status quo.

Even with the demise of riot grrrl in the face of debates about recuperation and what Hanna now sees as the structurally necessary result when "the world only treats you like a dot on a marketing scheme," this goal will persist into later forms of feminist punk production as various contradictory attempts are made to reinvent "the author as producer."

The Author as Producer: *J.D.s* as Queer Apparatus
In the founding homocore zine, *J.D.s*, the queer punk's refusal to affirmatively represent sexual identity expands political possibility. The roughly made zine, edited by both gay male Bruce LaBruce and lesbian G.B. Jones, is formatted as a black and white xerox, juxtaposing political polemics, lists of homocore bands, personal, and often erotic stories by Bruce LaBruce, erotic photos and drawings, comics, and letters from

readers. The interplay of these different forms of expression adds up to an intervention in Eighties-era aesthetics and politics, with the author serving as producer, breaching barriers imposed by specialization. Here, the zinester is not an artist who creates masterpieces, but rather one who gathers and recontextualizes cultural information and remakes technical apparatuses, turning readers into "collaborators" rather than spectators. This forms a kind of "mediated solidarity," reality as collective experiment, in which art does not produce situations but uncovers them.

By taking the stance of negation against neoliberal multiculturalism during a period that Lisa Duggan calls a class-war based "twilight of equality," *J.D.s* intervenes in the naturalized limits of representation. In *J.D.s*, this disruption upsets the categories typically used to mark identity politics, connecting gay politics to larger forms of collectivity, class politics, and feminism without sanitizing the sexual ecstasy at the core of these politics. To these ends, the short story "The Adventures of a Teenage J.D. and his Young, Eager to Please Punk" relays the ongoing saga of LaBruce and his boyfriend Butch. Here LaBruce unapologetically juxtaposes pornographic accounts with discussions of his affection for his younger sister and his reluctance to leave his family home. These relationships are shown not to be separate but symbiotic and the easy movement between emotional reflection and detailed accounts of sex disrupts the generic separation of these two categories, a disruption that is augmented by the breaking up of text by pictures of tattooed bodies and disembodied body parts, the tattoo operating as another form that blurs art and the everyday.

These forms of negation allow LaBruce to break down isolated categories. In issue three, LaBruce uses the overdetermined figure of the biker to narrate the complex semiotics of the juvenile delinquent. In the zine's central story

"A Bike of Her Own," LaBruce describes his encounter with Kit, a loner biker girl who has recently freed herself from an abusive father only to fall in with a group of macho bikers. In this story LaBruce takes care to distinguish the underworld culture he values from "macho" culture, and points to the difficulties of navigating these distinctions in a world where resilience and subcultural collectivity are entangled with homosocial aggressiveness. LaBruce describes his attraction to Kit in terms of her blend of masculine and feminine features, her toughness and tenderness:

> I was kind of afraid of her at first. She looked like a killer. But then while I was watching Butch get his new tattoo... she woke up and offered me one of her three chairs, and struck up a real friendly conversation with me. She was tough all right, when she wasn't running one or both hands through her short, bristly bleached hair, she had them planted on her knees. But then she'd lift her engineer boots on to the edge of her chair and hug her knees up to her skinny chest, and maybe tilt her head on a crazy angle and give you a sly, sideways look, and you could just tell she had her tender side too. (LaBruce, v. 2. 10)

Heterosociality creates reciprocal forms of insight for Kit and LaBruce. LaBruce begins to help his new friend explore lesbian identity, an identity that is presented as denaturalized and fluid. This heterosocial toughness is a reversal of the macho ethic of Kit's previous gang of bikers,

> who would stick their tongue down each others' throats to show how tough they were, but then beat up anybody they thought was a fag, like somebody who might look like they'd take their mother to a movie or something. (LaBruce, v. 3. 10)

Here, homosexual contact is coded as straight and macho, showing LaBruce's commitment to an expansive, politicized definition of queer culture. As the friendship between Kit and LaBruce grows, he describes forms of love that complicate the binary of sexual and nonsexual:

> And even though it didn't have anything to do with sex, riding behind Kit with my hands around her waist and my body pressed up against hers made me feel real safe and secure, like I could count on her for anything. (11)

This stability is contrasted with the couple form with its isolating and individualizing tendencies. The choppily typed story is disrupted by grainy images of female bikers, who exemplify this tough/tender ideal and who interlard the confessional text with a different kind of spectacular, cool and distanced imagery, "giving print a caption," as Walter Benjamin insists as a requirement for Epic theater.

Playing with Secrets: *Doris* as Popular Realism

The zine *Doris* is a variation of expressive negation in third wave feminism that exemplifies the expansion from zine culture to everyday life. In *Doris*, the categories of personal and political, individual and collective are disturbed by a focus on activity, craft, and the category of youth. Here, expressive negation navigates the lag between possibility and reality in a world where technological advance could allow for women's liberation – yet women still encounter intractable barriers to a fulfilling adult identity and sexuality. The zine alternates between harrowing autobiographical stories of sexual abuse and descriptions of the small pleasures of DiY projects. Here, female subjectivity is expressed as tragic closure in which

your insides are screaming and your outsides are trying to look cool and calm: When you can't hold in the secrets of your life, but to tell them in plain language would kill you...

On the other hand, DiY projects and playful sociality are framed in a comic mode with utopian goals:

Doris is about finding a life worth living and creating a world that will allow us to live, creating a world full of meaning, that we can thrive in, that we can come together in, where we will be heard, where we will be able to believe in ourselves, where we won't think our thoughts and emotions are crazy. A world where we will know for real that we are not alone.

This strategy of representation pits doing against being, activity against existence, experience against objectification. The girl zine not only presents a collective prefigurative politics but also maps contemporary impasses in the possibilities for a feminist identity politics.

Doris has been published from 1991 to the present. The genealogy of the zine stems from Crabb's teenage experiences of coming into gender identity and an early introduction to anarchism and punk. She went on to participate in a political collective in Minneapolis and then a collective house in Portland. She began to work on the zine when she moved to the Bay Area and now lives in Ashville, North Carolina where she is involved in many DiY projects. The tone of the zine stems from an expansion of her idea of the political. Having over-extended herself with political organizing, she describes having an epiphany when she realized that the revolution would not happen in her lifetime, and that the degree of social alienation that pervades the general culture makes our society unfit for sudden change. At this time she expanded her definition of the political from organizing to

a kind of consciousness raising that would prepare people for collective existence. This began with a concept of "the secret," a consistent theme in the zine, as she shares secrets about past abuse and insecurities, as well as secrets about her passions for people and everyday events. This is all in the context of general anarchist goals:

> that people have the capability to live in a world without oppression and without coercive institutions and government... it's basically the idea that people can self organize, that we can live without coercion, that we can live in an ecologically sustainable way. (Rasmussen)

Such ideology leads to a politics in which subjective expression stems from participation in anarchist sociality. In an interview with *Maximum Rocknroll* she charts the progression of her experience from DiY as remaking the self to DiY as remaking the community, as she gradually read about anarchism and adopted it as a life philosophy. This drove Crabb to seek out other punks who had adopted a life of anarchism and she became central to a developing scene in Ashville, North Carolina. Here, she helped transform the town into a counterculture mecca with thriving show and social spaces, developing a plan to create public, radical space.

Crabb's writing is compelling in its range of expressions and this is accomplished through eschewing traditional rules of writing, such as graceful transitions and succinct titles. Instead, form is directed by urgency and necessity, as in the title of one story: "when I thought my cunt was the only part of me that was worth anything, and only because boys could stick stuff in it." The unwieldy, direct and profane title follows Bertolt Brecht's prescription for an experimental form of politicized realism in which the rules of storytelling obey the needs of the story rather than "eternal aesthetic laws." He claims he

learned this lesson from a proletarian actor who transformed Brecht's attitude towards his own art: "At his polite smile a whole section of aesthetic collapsed" (Brecht 111).

Following such unorthodox aesthetic trajectories, Crabb acts as an autodidact who cobbles together stories according to the urgencies of her own political and personal struggles. She follows harrowing stories of sexual abuse with jarringly different stories of picaresque adventures with other anarchist friends, juxtaposing starkly different forms of embodied sociality. The presentation of both innocent reciprocity and female objectification in close proximity creates unresolvable tension. Crabb's friends' and her own projects and inventions are described as placeholders for an encompassing collectivity, a nebulous yet intelligible political community. The Minneapolis political collective in which she participated had been dissolved by the time she started writing *Doris,* but this brief moment of collective action becomes an enduring reference point for political possibility, rather than evidence of failure:

> We were way more than just all the things we did added up. We went to protests and made them sing with theater and energy and life. No slow marching, no boring old chants. We took over streets and passed out flyers that explained the complexities of the issues at hand. Some of us worked at a food coop, kicked out the manager and made it worker owned. We published a journal, helped public forums, we did direct actions and coalition work. Tried to create a prefigurative politics as well as a responsive one. There was so much strength in our politics then. There was this sense of urgency that we've somehow lost. We didn't have to wonder whether there was hope. We had to be that hope. We had to change things fast.

This utopianism must be credited as a counter-discourse to an individualizing neoliberal culture. At the same time, the fantasies of immediacy at play in *Doris* signal that, without an engagement with negation, the innocent and youthful discourse of DiY risks falling into the same logic that pervade a capitalist culture, a tendency that conflates the end of a masculine, industrialized Fordism as the triumph of freedom. Instead, Kathi Weeks warns against the uncritical elevation of feminized forms of behavior and labor:

> Though more interested in finding in caring labor another model of ethical work than in imposing the model of waged work on the practices of care, some of these second-wave authors nonetheless echo aspects of the ethical discourse of waged labor in making the case for caring labor's significance and worth. Thus the ethic of care could also be construed as an ethic of work. Beyond the long-standing problem of gender essentialism that haunts the project, this and other efforts to expand conceptions of what counts as work also risk tapping into and expanding the scope of the traditional work ethic. (67)

Thus, the naïve approach in *Doris*, in its elevation of reciprocity and collective self-care, can lead to a reconciliation with a deepened stage of capitalist subsumption which demands not only workers' obedience, but their flexibility, sociability, empathy, enthusiasm, adaptability, creativity, and "subjective investment" (70).

However, it is important to acknowledge the other registers of the optimism and engagement in such anarcha-feminist projects. By harnessing subcultural production to political eventfulness, *Doris* represents a recalibrated version of popular realism, as in Brecht's definition: "We have in mind a fighting people and also a fighting conception of popularity" (Brecht 108). Brecht describes this popular real-

ism as a constantly morphing technique, able to adjust to changing contexts, making a: "lively use of all means, old and new, tried and untried, deriving from art and deriving from other sources, in order to put living reality in the hands of living people in such a way that it can be mastered" (Brecht 109). This is a form of realism that is less about positive representation than about baring contradictions. The expressive negation in *Doris* represents this cobbled together realism in the hands of an anarcha-feminist youth subculture struggling to remake girl subjectivity as it encounters both blockades and passages to social transformation.

Conclusion

Expressive negation works in feminist punk DiY through an aesthetic of cut and paste, a focus on activity over identity and a refusal of positive and static forms of representation. As an elusive and constant form of negation, feminist punk DiY evokes a common figure for the dialectic in Marxist theory – Heraclitus' flowing river, which is always in the process of changing and becoming so that "no man ever steps in the same river twice, for it's not the same river and he's not the same man." The female punk avatar of expressive negation, Patti Smith, favored "pissing in a river" (an incantatory song on her album *Radio Ethiopia*) over positive declarations of feminism, to the chagrin of some who would take her as a feminist icon. Instead she created a Rimbaldian poetic mode in which poetic tropes, noise, "babbling," "incoherent speech", and dissonant orchestrations break through superficial and reified narratives of reality by creating the "primal, physical noise of the resacralized void" (Noland 598). In riot grrrl and queercore, we see these sublime forms of negation and anger in such aesthetic strategies as "kinderwhore," "kitty with a whip," and the general refusal of positive representation.

These feminist DiY practices arise in a moment of extreme fragmentation, where, as Maya Gonzales argues, the current proliferation of forms and positions of struggle allows only for a constant interrogation and expansion of patchwork and limited demands ("Communization"). The third spaces offered by DiY feminist culture allow for a mapping of this simultaneous closure and opening. Expressive negation is a symptom and a diagnosis of the impossibility and necessity of the affirmation of the category of "woman." In the face of this impasse, expressive negation is a tactic that has enduring effects on the everyday life of both the participants and the culture, serving "humanity's long history of refusal" (Connery, "World Sixties"). In this sense, the politics of feminist, queer, and anarcha-feminist punk expression can be seen as both a prefiguration and an allegory for a future, as-yet unimaginable transformation of everyday life.

Chapter Four

Modern Primitive Play:
Crimethinc's Folk Science

As the 2011 Occupy movement gained popularity and different figures and groups began to vie to define its direction and goals, longtime leftist political journalist Chris Hedges entered the fray, calling black bloc anarchists a violent "cancer of the Occupy movement," leading to widespread and varied reaction among activists and commentators. When he was challenged to a public debate, an agent of the group CrimethInc was selected as his opponent, championing "a diversity of tactics." CrimethInc comes to the fore during public protests as a symbol of militancy. Here, however, I want to analyze the collective for their lesser-known aspects. Their most well known book in the Nineties was called *Days of War, Nights of Love,* a series of playful and philosophical essays, influenced by situationist emphasis on the transformation of everyday life and the liberatory elements of insurrectionary revolt. Their most extensive work dwells on these utopian nights of love, and yet their public profile is limited to depicting them as enraged, masculine, black-clad trouble makers railing against the day. As the group themselves declare:

> Nothing makes people more defensive than the suggestion that they can and should enjoy themselves: this triggers all their shame at their failures to do so, all their resentment towards those they feel must be monopolizing pleasure, and a great deal of lingering Puritanism besides. ("Fighting")

While recognizing the limits of Crimethinc's ludic mode, this chapter attempts to understand the uses for theory and struggle in this euphoric mobilization of play.

CrimethInc began in 1996 with the Atlanta based zine *Inside Front*, dedicated to radical politics and hardcore punk. The loose knit collective came to be known for its pro-situationist propaganda and advocacy of DiY projects, wage-work refusal, and subversion of dominant institutions. CrimethInc "propagandists" (a stigmatized term they reclaim to emphasize their pedagogical, deeply politicized view of culture) have hubs in many regions of the US but are strongest in Atlanta, Georgia, Olympia, Washington, and Ashville, N. Carolina. Some major projects are the zines *Hunter/Gatherer*, *Harbinger*, *Rolling Thunder;* the books *Anarchy in the Age of Dinosaurs*, *Days of War, Nights of Love*, *Evasion*, *Expect Resistance*, *Recipes for Disaster*, and *The Secret World of Terijian*; as well as distribution of hardcore punk bands such as Catharsis, Gehenna, Kilara, Timebomb, Trial Umlaut, Aluminum Noise, Ire What Seed, What Root? Black Market Fetus, Breed/extinction, and Zegota. They participate in and propagandize many other projects such as the "black bloc" contingent of the "Battle of Seattle," the large scale 1999 protest of the World Trade Organization Ministerial Conference, and the Occupy movement. In their words, the major concepts CrimethInc introduced in the Nineties were: immediacy, decentralization, do-it-yourself resistance to capitalism, anonymity, plagiarism, crime, hedonism, the refusal of work, the delegitimization of history in favor of myth, the idea that revolutionary struggle could be a romantic adventure ("Fighting").

CrimethInc's publications circulate in the thousands and they have a highly visible web presence. Their aim is to encourage young people to drop out of work and school regimes in order to dedicate themselves to direct action and militant play. Their readers – "travelling kids" or CrimethInc kids – work to build a drop-out culture based on mutual aid, sponsoring projects such as infoshops, zines, punk bands, Reclaim the Streets, black bloc affinity groups, squats, Food

not Bombs, and independent distros. CrimethInc publications and projects often implicitly frame their aesthetic/ political project through Raoul Vaneigem's concept of "the revolution of everyday life" to form an alternately playful and serious anarchist utopian counterculture.

Following the situationists, CrimethInc sees play as an antidote to and negation of a life lived purely as survival or passivity. Play is seen as voluntaristic world-building, a transformation of the world "from the frightening, alien place that it is, into a place ripe with possibility, where our lives are in our own hands and any dream can come true" ("Between Life and Survival"). CrimethInc counters "boring" mainstream politics with a prefigurative mode that would make revolution "a game played for the highest stakes of all, but a joyous, carefree game nonetheless" (Nadia "Your Politics"). For CrimethInc, there is a "secret world concealed within this one" to be unearthed by ludic poesis in an ecstatic mode. Poetic activity itself is seen as a sign of immanent revolution. In a passage from a CrimethInc tract, the call for poetic revolution and the ecstatic mode of delivery are insuperable:

> When poets and radicals stay up until sunrise, wracking their brains for the perfect sequence of words or deeds to fill hearts (or cities) with fire, they're trying to find a hidden entrance to it. ("Secret World")

This poetic manifesto sets spontaneous youth against the ratiocinated modes of adulthood.

> When you're young/and it feels like you're invincible, /
> it's because you are. /From this moment forth, /
> no one shall ever die. ("Manifesto Part 72")

Against the neoliberal rhetoric of spoiled youth that need to be disciplined by austerity and scarcity, CrimethInc frame

youthful exuberance as a kernel of revolutionary revolt. For Ernst Bloch, youth's voluntaristic, prefigurative politics allows for an imaginary "ripe for expression, forming and execution" (Bloch, *Principle* 124). Youth are the lightning rods for this "not yet conscious state," occupying the heart of change and productivity (117). In youthful play, the slow preparations for change are obscured by the experience of spontaneity, thus creating the galvanizing illusion of transformative power. This, what Henri Lefebvre calls in his work on the French May 68 uprisings the "possibilist mode," allows for a point of purchase from the limited terms and concepts offered in rationalist, liberal discourse, as in Frances Fukuyama's contemporary notion of liberalism as a final horizon, "the end of history", or the Thatcherite dictate of TINA (There is No Alternative).

CrimethInc see themselves as inheritors of anarchist activity that stretches back to prehistoric modes of living. In one of their many introductions to anarchism, the "Fighting for Our Lives" pamphlet, they frame this lineage as one long narrative of spontaneous magic victories against the telic violence of history in which they

> fell in love in the wreckage, shouted out songs in the uproar, danced joyfully in the heaviest shackles they could forge, we smuggled our stories through the gauntlets of silence, starvation, and subjugation to bring them back to life again and again as bombs and beating hearts..." ("A Genealogy")

Creating a broad historical subject, an enduring anarchist "we," CrimethInc draw on the theories of hunter/gatherer culture by Marshall Sahlins to invent a mythology of anarchist prehistory as an integrated life of mutual aid where work and play are one. However, this exuberant mythology also serves as a self-reflexive engagement with modernity

through expressive negation. For CrimethInc, there is "No Future in Nostalgia." The absolute limitlessness of anarchist prehistory is tethered to its failure, its brief flash as a Temporary Autonomous Zone. They adopt the situationist understanding of the tribal, in which the group are

> ethnographers of their own difference, cartographers of an attitude to life. This life did not lie outside the modern, Western one, but inside, in the fissures of its cities. It did not yearn for a *primitive* life from before history, but rather for one that was to come after it. In the life of the Saint-Germain delinquents' *tribe* could be found particles of the future, not the past, and not from some colonial Donogoo Tonka but from the very epicenter of what history had wrought: the colonization of everyday life at the heart of empire. (emphases Wark's, *Beach* 22)

Anarchism has thus far never entered history, and its lineage serves as a reminder of the possibility of seemingly impossible transformation, a prefiguration of future utopia, as in their appropriation of premodern myths of the Aborigines in "a time that runs concurrent with mortal time, as well as having taken place at the inception of the cosmos" ("One Million").

CrimethInc values scientific discovery and artistic invention but notes that specialized versions of these practices drain them of their power and insight. Under the regime of "separation," science becomes utilitarian while art becomes mere style, elevated by critics and historians concerned with preserving their status. In contrast, CrimethInc's "folk science" reclaims process and discovery, rejecting the "priest caste" of artists and scientists who mediate between the "lowly individual" and "the universe, health, happiness, even love" (*Days of War*, 182).

Folk science extends to all activities — even such intimate practices as kissing become the "business of experts" in media and pornography. CrimethInc's critique of these forms of objectification goes beyond feminist notions of exploitation to a larger understanding of pornography as alienation of women and men from their desire. Bricolage cites "primitive" means of expression, originally used to designate a "science of the concrete," a kind of knowledge at work in premodern forms of magic and myth that challenged enlightenment rationality. However, this method is firmly entrenched in modernity and "style" by and for a culture steeped in consumption and commodities. These are "structured improvisations" that Hebdige argues can be tied to Umberto Eco's notion of "semiotic guerrilla warfare," or "surrealism's war... on a world of surfaces" (104-105).

DiY Play and the Hobo Sublime

DiY forms of work refusal emerge in crisis, and a precedent to ludic DiY cultural politics can be seen in the collective hobo culture of the great depression. The figure of the tramp is a model of resistance to wage work, domestic work, the family structure, and sexual morality, operating as a "figure of indulgence and indiscipline" (Weeks 165). Refusing "dominant instructional sites of work and family," both male and female tramps upend patriarchal forms in favor of promiscuous alliances with temporary employment and partners. The hobo denaturalizes the elevation of work and family. The anti-asceticism of this figure sows the seeds for alternate forms of temporal and spatial logics. This form of diagnostic and militant logic lets us "think these two elements of the concrete utopia together: the commitment both to the real-possible and to the novum..." allowing the flexibility to map the future potentiality, "that which we must map cognitively and that which necessarily exceeds our efforts at representation" (Weeks 197).

While CrimethInc draws its iconography from many historical iterations of "the dropout," the hobo is central to their mode of expression. The early 2000's tract *Evasion* has become a legendary text in the punk appropriation of this icon, beginning as a hundred page zine until republished by CrimethInc as a DiY book. *Evasion* operates as a "how to" or pedagogical manual, and at the same time it entertains with lively accounts of travelling adventures. CrimethInc introduces *Evasion* as a gateway text, a passageway between dropping out of one world and building a new one, as one's "skillz evolved." These new forms of hobobos (hobo bohemians) or hobocore/crusties (neo-hobo travelling punks), map out a neo-hobo structure of feeling, often travelling by hopping box cars and forming road collectives, opening themselves to the vagrant vicissitudes of despair and hope. The protagonist and author Mack's voluntary poverty leads him to expound a hobo cosmology:

> Evidence was mounting to suggest the presence of a hobo god, an eternally filthy and drunk celestial guardian who saved punks from train crashes, left doors unlocked at critical moments, and made rational people throw everything imaginable into dumpsters. (14)

In *Evasion*, the protagonist forms a plan for post high-school life, in which he can hold onto a child-like sense of play, but translate this to reconfiguration of everyday life, forming elaborate schemes and projects to avoid wage labor and cobble together the necessities for happiness and survival from the detritus of a wasteful suburb in Southern California: "Their sterile landscape would be my carnival." The author advances a carnivalesque, topsy turvy philosophy that posits a "seemingly backwards correlation between poverty and satisfaction" (118). In this world, mundane details of life become precious;

a small refund for bus fare or a free dumpstered pizza become enchanted tokens of the achievement of this possibility:

> Burdens are lifted and scarcity is averted when the mountains of trash produced by this insane society become supplies and sustenance. Everything that sucks about capitalism is inverted when the dumpster diver scores. Poverty becomes abundance. Loss becomes gain. Despair becomes hope. (119)

The discursive precedent for Mack's utopian hobo figure can be seen in the tradition of depression-era hobo picaresque writings. *Bound for Glory*, Woody Guthrie's fictionalized auto-biography, provides a vernacular counter-discourse that is later drawn upon by CrimethInc's "travelling kids." The novel's tropology privileges jumble and disorder, puncturing the telic trajectory of failure and tragedy that characterizes most fictional depictions of poverty. Early on, our protago-nist hops onto a boxcar and the topsy turvy world of the ludic everyday is prevalent:

> I could see men of all colors bouncing along in the boxcar. We stood up. We laid down. We piled around on each other. We used each other for pillows. (19)

In this short passage we see racial diversity, disorder, adven-ture and intimacy, qualities that replace linear narrative as a mode of unifying the novel. The characters in the boxcars and bars that populate Guthrie's novel speak in the heavy ver-nacular that characterizes proletarian linguistic play. Always engaged in vertigo (transformation of perception) and agon (competition) – two of the four categories of play set out by foundational play theorist Roger Caillois – hobo vernacular is laced with insider codes and colorful phrases that reveal expression as itself a game. Unlike the relentless telic thrust

of the typical naturalist novel depicting the poor – Zola, Hardy, Dreiser – the use of the picaresque mode conveys the lack of instrumentality and tragic consequence that characterizes hobo-culture's sense of play.

Play is purposeless, free from the 'pitfalls of teleology.' Quentin Stevens describes play in the form of paidia, characterized by "diversion, destruction, spontaneity, caprice, turbulence and exuberance" (33). *Bound for Glory* follows this mode as scenes proceed into capricious byways, in the manner of jokes that skirt comedy and tragedy, as the hobo life leaves the protagonist in a liminal zone between poverty and abundance:

> Too much for chili. Not enough for beef stews. Too much for sleeping outside, and not enough for sleeping inside. Too much to be broke and not enough to pay a loafing fine. Too much to eat all by yourself, but not enough to feed some other boomer. (247)

The ludic mode is a play between what isn't, could be, should be possible, a form of critical cognitive mapping, insisting on a capacious logic that allows for both present and future, realism and utopia.

Another precedent for Crimethinc's hobo discourse is set by the 1937 novel *Sister of the Road: The Autobiography of Boxcar Bertha,* a fictitious autobiography whose protagonist is a composite character of those encountered by the author Ben Reitman during his experiences as an anarchist hobo and doctor to the impoverished. Bertha is depicted as a poor but cheerful adventurous woman who can find pleasure in the everyday and shows no special adherence to social conventions or traditional women's roles in marriage or domesticity. Her story serves as a counternarrative to hegemonic instructive novels for woman – Bertha begins life with a

single mother who is neither tragic nor unhappy, and whose sexual looseness in no way conflicts with her essential goodness and warmth. In Bertha's rearing, play is not spatially or temporally constricted, the ludic is not restricted to toys, games, or even art or sex. Necessity determines that Bertha must treat all life and all space as a playground; every item she gleans serves as a toy or pleasurable object. In the world of these poor hoboes there is a prefigurative politics that frees gender, marriage, sex, family from the ratiocination and stricture of possessiveness and private property. Sex and love become pure play, and a mother's advice to her sexually curious daughter is:

> If a man wants you and you want him, just take him. There isn't much to it. I have had all kinds of lovers and it never did me any harm... Men are wonderful. When you get tired of them, or they of you, leave them without bitterness and regret. (Reitman 28)

Eventually, Bertha ends up sharing a lover with her mother, with her mother's blessing, and this, like other broken taboos in the novel, does not bring on any tragic outcome. Reitman depicts a world of generosity, porous boundaries, and lack of fear. When Bertha and her female friends want to ride the rails they drop by a "hobo college" and are given generous advice and a ride from a man who defies novelistic codes and has no sinister intentions. Later in the novel Bertha does suffer hardships due to failed love relationships and poverty, but this does not cancel or contradict the liberatory tone of the novel's early chapters. Her trajectory invokes Madeline Lane-McKinley's argument regarding the spatial politics of utopian sixties communes whose politics of "failure" were productive in generating counter-discourses but whose lack of fixity was always a foregone conclusion (*After the 'Post-6os'*).

The rafting trip I discussed with two Santa Cruz anarchist friends, Jenn and Bey, brought out the flexible nature of the CrimethInc hobo ethos. In 2007, they and ten other people built their own rafts from gleaned plywood and tires, brought along motley supplies and spent ten days on the Willamette River. The bricolage and improvisatory character of the trip was apparent in every leg of the journey; made by anarchists who had adopted neo-folk styles borrowing from hunter/gatherers, Native American and other indigenous people, the early 20th century hobo, Appalachian and other American folk cultures, hippie, yippie, Digger, punk, neo-primitive, characters from science fiction and pagan fantasy. Singing was a central pastime of the trip, and the songs chosen show an expressive affiliation with folk forms:

> JC: We did the most amazing harmonies. We were all singers. All of us were musical, it was a very musical time in Santa Cruz.
> JI: Do you remember the songs you sang in the Boxcar?
> JC: Not sure, (hums) oh it was "I Wish I was a Mole in the Ground."

The song is a favorite from the *Anthology of American Folk Music*, part of the folk revival and still popular with American folk and old timey fans, now absorbed into the hobo components of punk youth style. The lyrics were central to Greil Marcus' conception of the US as an "Invisible Republic":

> I wish I was a mole in the ground / Yes, I wish I was a mole in the ground / If I'se a mole in the ground, I'd root that mountain down / And I wish I was a mole in the ground.

Marcus' "Invisible Republic" is framed as the other side of bellicose and capitalist myths, a haunting place where subversive counter-histories can be felt if not fully articulated.

Marcus sees in the mystery of these songs, and their legacy in Bob Dylan's basement tapes, a folk culture that looks at life as a "void that looks back." Foregrounding negation over authenticity, the concept of the void provides an empty space for remaking, bricolage, anti-specialization: the work of folk science. Jenn, cobbling her raft from plywood, inner tubes, and styrofoam, described turning away some help from a more experienced raft builder: "I just want to experiment. I don't want to know all the details."

The rafts exhibit a simplicity and fragility that demonstrate the tenuousness of this folk science project. It is politics in an age of depoliticization – the absence, following the end of the Sixties, of a powerful global resistance movement. In the face of this, bricolage provides a supple method of navigating contradictions and mapping out possible futurities. Norman O. Brown used the analogy of "trying to build a raft out of the ruins of a shipwreck" to describe the process of finding a visionary poetics in a politically dark moment (for him the moment of Thatcher and Reagan). For Brown, this politics is the negation of certainty: "To be a poet is to be vulnerable. Odysseus on his raft." Neo-hoboism can be seen in relation to the image of the river, as Jameson describes it, in Bertolt Brecht's representation of precapitalist folk forms. The river allows for representation of praxis in a moment of stasis: "the change or flowing of all things; for it is the movement of this great river of time or the Tao that will slowly carry us downstream again to the moment of praxis" (Jameson, *Brecht and Method* 1).

Never Work

CrimethInc extend this embrace of play to a critique of work. In the Nineties CrimethInc's central message was to follow the Situationist slogan "never work" and much of the culture they developed came from experimenting with negating the

division between work and play in their own lives by dropping out of the wage-earning regime. They have since admitted that these experiments in joblessness have become predictors of a more entrenched stage of enforced immiseration: "It turns out capitalism has no more use for us than we have for it... Now erratic employment and identification with one's leisure activities rather than one's career path have been normalized as an economic position rather than a political one." However, they do not disavow their emphasis on developing new ways of living. Instead, they find it all the more urgent to mobilize these new skills to "interrupt the processes that produce poverty" ("Fighting").

The Eighties anti-work zine *Processed World* can be seen as a precursor to the CrimethInc ethos. *PW* contains anti-work themed humorous, theoretical, and historical articles, reports on actions, manifestos, and the *détournement* of bureaucratic language and culture. The zine was created by a "post-New Left, post-situationist libertarian radicalism and the dissident cultural movement whose most public expression was punk and new wave music" (Carlsson, "Some History"). The writers, frustrated artists and activists working in the financial district of San Francisco, saw late capitalist work as mostly useless, and advocated moving toward a utopian society where work played a small role, citing a lineage of anarchist, utopian, and Marxist theorists who saw the lessening of the work day as a primary goal. Their temporary, go nowhere jobs, they knew, were symptoms of exploitation and worker obsolescence. But this flexibilization provided space for autonomy and creativity. They did not have radical unions or mass organization, but they did at least have the capacity to point to this lack, by disruption through games and satiric play such as a stock market stench bombing.

The zine features advertisements for imaginary products such as a "pocket futurist" that will excrete wafts of holo-

graphic optimism, reassuring the purchaser that "people in charge know what they're doing." In response to a coercive environment, *PW* finds ludic forms of sabotage, recombining and making poetry of their banal office supplies and implements to provoke negation and critique. A *Processed World* poem uses the language and instruments of the office to form a succinct punk critique of banality:

> &7 black beauties / The Void of Annual report / Senseless Paper work / Silly Dictaphone / Vacant as hell / 5 days a week / & heaven at five.

This attack on the tools of work, coupled with punk vernacular, provides a language that can counter a discourse of professionalism that pervades even progressive realms. This is a necessary form of critique in an era where NGOs and non-profits have colonized much of the terrain whose logic was formerly harnessed to direct action and anti-capitalism. Further, where once professionalist logic was limited to a certain set of skills and training, neoliberal forms of work demand that this ethos pervade what Arlie Hochschild calls "the managed heart," through such private realms as "thoughts, imagination, relationships, and affects" (Weeks 73). Punk negation, here, serves as a means to combat the bureaucratization of emotional life.

CrimethInc tracts continue this situationist project of attacking the work ethic, arguing that sanctioned forms of both work and leisure are emptied of desire by specialization, repetition, and alienation. The critique of work, then, is here a critique of passivity. Instead of work or leisure, CrimethInc advocates the creation of projects. Unemployment should not be thought of negatively, says Gregarious, an intentionally jobless CrimethInc agent, rather it is doing what you want, and a way of highlighting the fact that many people

lack the ability to be creative or self directed (*Days of War* 245). We should be defined, argues Henri Lefebvre, by this voluntary play; forced labor is not culture, it is a fetishization of the work ethic, an ascetic denial of pleasure. CrimethInc concurs:

> There are a thousand reasons not to work – to enjoy life more, to avoid the humiliation of putting a price on your time or wearing a uniform or having a boss, to deny the capitalist market your labor. And when I say 'not work,' I don't mean doing nothing instead, I mean having your time to spend on what you want to do. I think one of the best reasons to not work is the fact that so many people can't imagine what to do instead. You have to have the chance to reclaim your ability to direct your own energy. I wouldn't be able to do so much activist work, or travel so much, if I had a normal job – that's for sure. (*Days of War* 245)

Work refusal is more than not working, it is a refusal of the capitalist division of labor, space, and time as units of productivity and consumption, and it is an unpacking of what Kathi Weeks sees as the antinomies of the work ethic: rational/irrational, productivist/consumerist, independence/social dependence, subordination/insubordination, exclusion/inclusion (42). Instead of a dreary segmented world where even sleeping is done for the boss, Crimethinc gestures toward a "practice of lived time," a reconfiguration of everyday life (Wark, *Beneath* 25).

In CrimethInc's writings, work refusal is a broad concept, extending to such activities as daydreaming and slacking on the job. Here, work is defined as "labor that takes more from us than it gives back, or that is governed by external forces" (*Work* 17). Work refusal allows for alternate imaginations of human collective activities on the model of "Festivals, feasts,

philosophy, romance, creative pursuits, child rearing, friend-ship, adventure." They ask: "can we picture these as the center of life, rather than packed into our spare time" (*Work* 75)? Under the work regime we are robbed of the "real security" of being a part of a community based on mutual aid. Such insti-tutions as the star system are shown to symbolize our stolen creativity, with superstars representing "the creative poten-tial of all the exploited, purchased from us, concentrated and sold back" (*Work* 75). Instead, they argue for a folk culture from below: "The more people invest meaning in their own lives and social circles, the more powerful and capable they are likely to be" (*Work* 75).

CrimethInc periodizes its own form of work resistance in a post-Fordist context while looking at its continuity with historical precedents. The work regime is seen to expand to realms of control beyond the point of production, as CrimethInc points to demobilizing and immiserating effects of the "social factory." CrimethInc's denaturalization of work echoes the arguments of Kathi Weeks, who registers the diffi-culty of criticizing the work ethic in an era of privatized labor, noting that "we often experience and imagine the employ-ment relation, like the marriage relation, not as a social insti-tution but as a unique relationship" (3). For Weeks, work must be denaturalized since the idea that a living must be earned "is taken as part of the natural order rather than as a social convention." Criticisms of work are lobbied at particu-lar jobs rather than the generalized condition and ubiquity of work. Work is the primary form of socialization and citizen-ship, allowing dreams of collectivity to be derailed and appro-priated. Leisure becomes an extension of work as "capital's productivist ethic" prescribes suitable and rationalized levels of indulgence (51).

This critical focus denaturalizes the idea that work is the only way to organize the will to creativity and activity. A focus

on work and work refusal allows for an expansive sense of struggle that includes "the command and control over the spaces and times of life, and seeks the freedom to participate in shaping the terms of what collectively we can do and what together we might become" (Weeks 23). The anti-work wager of "folk science" is that it allows a collective imagination as a counterpoint to the individualizing discourse of the work ethic that creates a "sovereign individual subject of exploitation" (Weeks 51). The hope is that this will provide "the building blocks of communal solidarity" for and by the motley new subjects that emerge from post-Fordist labor reconfiguration and recomposition of the working class (Carlsson, *Nowtopia* 5).

A Tile in the Mosaic: Spatial Play and DiY Games

This ludic engagement with the everyday often takes the form of DiY games that have a lineage with previous forms of working class and children's street games. The games of the poor serve as a kind of bricolage of the street, temporarily turning abject conditions into spaces of freedom and adventure. Such street games are adapted by CrimethInc and other youth oriented DiY projects, and serve as contemporary ludic explorations of the everyday. The poor cannot afford expensive specialized equipment, so by force must engage with and remake everyday life in order to escape the seriousness of adult ratiocination. The public, communal, intimate and rough streets of urban areas such as New York ethnic boroughs form the background of a utopian imaginary, described by Fred Feretti as such: "The block was our universe, and on it, there was usually enough of everything for us" (14). These games allow for both an understanding and contestation of postmodern forms of global homogenization, fragmentation, and unity.

The situationists reconstructed this spatial play in the form of "situations." For this revolutionary grouping, games

and urban exploration enlarge life, pointing to the scale of transformation that will characterize revolutionary change. In this logic, "Critical play," the term Mary Flanagan gives to subversive, socially oriented games, will develop new desires, new constructions of the environment and behavior. In turn, these emergent sensibilities and new ambiences may prepare a context for objective forms of revolution. However, "to do this, we must from the beginning make practical use of the everyday processes and cultural forms that now exist, while refusing to acknowledge any inherent value they may claim to have" (Debord, "Report" 22). Situationist play is not invention but reinvention, bricolage, the reuse of forms, materials, ideas, to create fleeting "passages" to new states of being.

My interview with Pat supported the notion of anarchist games as supple engagement with the possibilities and impasses in everyday life. For three years after graduating college Pat was immersed in the Santa Cruz DiY scene, and a large part of the scene was playing games: "The Village," "Rant-A-Wheel," "Combat Kissing," and others. He described his experience of playing "capture the flag," an event in 2007 in downtown Santa Cruz. The game is popular in the DiY scene and is frequently written about in CrimethInc zines. The players divide into two teams and the objective is to capture the other team's flag. The flag is hidden on the team's "territory" and must be captured, but when players enter the other team's area they are in danger of being sent to "jail" through being seen, outrun, and tagged. Pat is keenly aware of this game as a psychogeographic experiment, confronting gentrified urban spaces by creating new ambiences and dynamics. The effect of the game was to have the anarchists interact and play in ways that weren't possible in the "real world", and to make physical interventions into quotidian forms of errands and entertainment.

Much of the energy behind anarchist games is figured in the ecstatic mode. In CrimethInc descriptions of play, adventure and the strength of youth become metaphors for a voluntaristic ability to transform the world. One player feels an animal-like keenness, a life of "fire and intensity":

> Our city was coming to life in a way it never had before, and we were making it happen. This space, normally designated for dumpsters, automobiles, and consumers, was becoming liberated territory. As that moment passed through me, I found myself airborne, diving to tag what I now imagined to be a political prisoner, to free us both from the constraints we fight against everyday.

The game was a means to re-enchant, to capture "a long lost world once characterized by wonder and possibility," while serving the pedagogical purpose of training anarchists in tactics that could contribute to struggle. Capture the flag is described as an analogous game to *parkour*, a French sport that many anarchists have developed some interest in, in which people attempt to move in a straight line through the city by climbing or leaping walls, fences, buildings, and any other obstacles. The "*traceur*" or "*traceuse*" must adapt to his or her environment using their agility and ingenuity serving as "an instance of the unruly intersection between capital flow and the flow of human bodies; instead of coinciding, they may intersect at angles of varying and appositonal intensities" (Thomson 251-252). This sport is popular in the impoverished immigrant banlieues of France, demonstrating tenuous faultlines on the tipping point between capitalist city and planet of slums, again contributing "a tile in the mosaic" of proletarianized psychogeography.

In an age permeated with the discourse of postmodern play, and the supposed liberation it will bring, one must

be wary of utopian framings of the ludic mode. As Benjamin Noys argues, the comic mode can become an affirmative replacement for critique in the form of an anti-political vitalism ("The Poverty of Vitalism"). However, it is equally perilous to fall into the discourse of "maturity" and austerity, advocating a pragmatic "realism" in the face of "childish" hope. DiY is strongest when it moves away from an affirmative relation to the ludic mode, and gravitates toward a situationist notion of play as utopian spatial negation. Here, there is an attempt to detach the ludic mode from consumerism, affirmationism, and the globalized image of "choice." Rather, ludic bricolage can be a transitional means to expand the "nonmediocre" parts of life, reduce "the empty moments," refuse boredom. The player seeks out charged ambiences, unpredictable situations, "taking a stand in favor of what will bring about the future reign of freedom and play." CrimethInc games are a means to refuse capitalist competition while embracing militancy; they "throw new forces into the battle of leisure" (Situationist International, "Contribution"). CrimethInc play is not in itself wholly ludic, it is part tragic, part failure, part struggle; it is "the preparation of ludic possibilities to come." In this spirit, CrimethInc has constructed an imaginary future culture that has written its own playful, mythical prehistory, in order to build toward a future revolutionary subject. These games and ludic projects are not to be preserved, but rather serve as mobile, transitory, "passageways" to a transformed future. DiY games and play as "expressive negation," are meant to multiply poetic subjects and objects in a banalized, depoliticized moment.

Chapter Five

Impractical Politics:
The Dialectics of Occupy

CrimethInc's mobilization of a youth-oriented ludic mode provides a counterpoint to "common sense" discursive formations that encourage passivity in the name of maturity and realism. This epistemological dimension of CrimethInc has been largely ignored in the cases where the group is most visible, its participation in global summit protests and in the Occupy movement. Instead, CrimethInc has been made to represent black bloc tactics and has come to be seen as the face of "violence" that disrupts the work of a nonviolent mainstream. In the many debates surrounding CrimethInc's tactics, the definition of violence is never pinpointed. At times it refers to Crimethinc's apparel, occupation of privatized spaces, symbolic property destruction, de-arrests, and occasional physical response to police attacks. This reductive definition of violence and its identification with CrimethInc's range of activity points to larger epistemological limits in thinking about the Occupy movement, including a naturalized, populist anti-utopianism that reflects general impasses in political thought.

As CrimethInc argues, the discussion defining violence in relation to political actions, "never takes place on a level playing field; while some delegitimize violence, the language of legitimacy itself paves the way for the authorities to employ it." This is particularly evident in the stark example of a newspaper reporting, during the 2001 Free Trade Area of the Americas (FTAA) summit in Quebec City, that violence *broke out* when protesters threw tear gas canisters that had originally been thrown at them or when UC Berkeley authorities deemed linking arms a form of violence ("The Illegiti-

macy"). The framing of the term "violence" can be a matter of life or death to many dissidents, as can be seen in Mubarak's Egyptian leadership, which reestablished legitimacy through separating out the "thugs" from the ostensibly good people. In the case of Egypt, this created a category that can legitimately be subjected to extreme state violence, and a logic where "*the infliction of violence itself* would suffice to brand its victims as violent – i.e., as legitimate targets" ("The Illegitimacy"). Once defined as violent, CrimethInc's "dangerous," "counter-productive", and "impractical" behavior is taken very seriously by its critics. However, black bloc practice has an epistemological dimension that needs to be explored with more nuance. It is imperative that anti-capitalist commentators do not fall into right-wing framings of the black bloc as pure violence and that we attend to the utopian dimensions of these actions. To that end, I want to make the controversial argument that some tactics branded as "violence" can be seen as an extension of the kind of play and expressive negation I have described above, and that in that capacity they are effective as both a form of prefiguration and cognitive mapping.

In a first-person testimonial, "Black Bloc Confidential," CrimethInc provides evidence for this epistemological reading of the black bloc. Here, the anonymous author makes few claims about the immediate pragmatism of black bloc tactics and instead frames them as a kind of poesis and "sentimental education." Tellingly, the black bloc tactics in Occupy cannot be narrated without the author's personal and political history. For the author, their involvement with these practices is framed as a part of the coming of age process in which subjectivity meets objectivity, the individual confronts her social historical context. While pragmatists evaluate black bloc tactics by excising them from the lives and social relations of participants and describing them as either working or

not-working, this testimonial reframes this range of tactics and actions in the light of the role of culture and its relationship to everyday life:

> It's more of an aesthetic development in the art of street confrontation. The black bloc is a methodology of struggle; it goes beyond a single color, and its intelligence reaches beyond the terrain of protests. ("Black Bloc Confidential")

Using the collective pronoun "we," the CrimethInc agent narrates black bloc tactics as the coming of age of a political generation estranged from the electoral political process, attuned to racialized state violence, and ruled by commodity logic. With a mix of exuberance and self-deprecation s/he paints a picture of precarious, isolated youth vacillating from hope to despair as they forge a tenuous collective identity through political battles and mutual aid:

> We find each other: the stupid, isolated, alienated, and utterly lost children of capital, just beginning our downward spiral— just beginning a precarious life, without promise and without hope... ("Black Bloc Confidential")

Here, scaling walls and running through streets in the course of Occupy actions is framed in continuity with the games and urban experiments that form the backbone of CrimethInc's expressive negation. The author admits these gestures can be frivolous, absurd and foolish, but, s/he insists, they are also a "dream of the abolition of capitalism."

Arguing against critic Chris Hedges who, in a widely circulated article in *Truthout* called the black bloc "the cancer of the Occupy movement," the author refuses to dismiss a core hunger for transformation that drives the black bloc activities:

The "cancer" that Chris finds so disturbing – the contagion of an anonymous collective force – is precisely why and how it continues to outlive every social movement from which it emerges... we *need* to fight, and not just in the ways our rulers deem justified and legitimate. ("Black Bloc Confidential")

As a small minority group and in the face of a missing mass movement, the black bloc reacts to this need pedagogically, trying to evaluate their situation. The author sees the black bloc as

the site for a new *sentimental education*: a political reordering of our sentiments. We learn new sensations of love, friendship, and death through the matrix of collective confrontation. In the obscurity of the black mask, I am most *present* in the world. This unfamiliar way of being compels me to focus and intensify my senses, to be radically present in my body and my environment. ("Black Bloc Confidential")

This conception of black bloc tactics as laboratory, experiment, drift, cultural revolution, prefiguration or cognitive mapping can and will be dismissed as trivial, distracting, destructive to "real" political work and organization, and it can be destructive or even counter-revolutionary if it is seen as mutually exclusive to other approaches. However, this element of a diversity of tactics prevents the "real" from eclipsing the possible.

Against reductive framings of CrimethInc and the black bloc as masculine, violent disrupters of nonviolent, pragmatic movements, I want to show both the contributions and limits of this situationist-oriented approach to occupation. Like the ballerina portrayed in the initial call for Occupy Wall Street in the culture jamming magazine *Adbusters*, CrimethInc's actions represent a precarious yet gracefully

adept voluntaristic movement in tension with the intransigent, masculine financial sphere. My use of this image from Adbusters is an intended as a détournement. For *Adbusters* this image connoted a voluntaristic victory of the populist 99% over the machinations of finance. Instead, I am arguing that the forces of rebellion must be understood as symptoms of as well as responses to contemporary forms of political economy. Black bloc tactics, in this sense are victories as well as failures. Its victories are temporary and some might say pyrrhic. However, the rhetoric of failure and impracticality often contributes to the dismissal and infantilization of radical and utopian gestures in the name of an elusive maturity. Neoliberalism is consistently defended in the name of realism and a whole constellation of accompanying dichotomies – maturity against childishness, austerity against excess, moderation against radicality, peaceful protesters against rioters and "outside agitators." However, CrimethInc and the black bloc deserve an anti-capitalist discursive framing rather than a "grown up" one.

This "grown up" critique is represented by Chris Hedges, who called the black bloc the "cancer of the Occupy movement" who can "only be obstructionist", and Todd Gitlin, who dismisses the utopian current of the Occupy movement in favor of what he sees as a nonviolent pragmatism. Gitlin, a prominent New Left activist turned critic of "cultural politics," creates a dichotomy between Occupy's "expressive impulse" and ostensibly practical forms of activism, implying a worldview in which utopianism and pragmatism form a clear binary. For Gitlin, the Occupy movement was predestined to fail because of its counterculture origins, its "anarchist post-punk core – often of anarcho-syndicalist and Situationist inspiration – that proclaimed itself 'horizontalist' and 'anti-capitalist' and 'revolutionary' and had no qualms about doing so."

Gitlin does not consider democratic processes such as the general assembly to be forms of decision making but extensions of a stagnant theatricality:

> It wanted itself. It wanted the euphoria of its existence. It wanted to be. It wanted to be what it was.

Chris Hedges goes further by drawing a stark line between black bloc anarchists and nonviolent protesters, claiming the former are a sabotaging "cancer of the Occupy movement" who can "only be obstructionist."

In contrast, Hedges sees nonviolent protest as practical in that it constitutes a threat to systems of power because of its widespread appeal. This ignores the fact that nonviolent forms of the Occupy movement were prone to failure in the face of the greater violence of the state. For Gary Kimaya, these impractical traits arise where the Occupy movement meets situationist thought. In his framing, the situationists represent an extreme of impracticality, that is a "grim, pedantic, hectoring" form of insanity and crude apocalyptic ideology. His assessments reflect a typically neoliberal discourse in which "totalizing" theory including Marxism, jargon, theology, paranoia, intellect, childishness, excessiveness, are set against pragmatism, neutrality, and common sense. As David Graeber compellingly argues, these critiques are not only flawed, they also pose a danger to activists and potential allies. Ostensibly "nonviolent" protesters have been known to exclude, assault, and turn black bloc participants in to the police in the name of pacifism. A more useful reading of DiY culture attends to the productive coexistence of utopian prefiguration and theoretical evaluation in these gestures, and channels criticism internally through the movement, rather than denouncing militants in an attempt to placate those whose job it is to frame the movement's desires as "the

random, silly blather of an ungrateful and lazy generation of weirdos" (Rushkoff).

Although there are, of course, situations where militant tactics are the wrong choice, CrimethInc's extension of play into the field of protest is a meaningful incursion into the rhetoric of maturity and pragmatism. In an article criticizing CrimethInc, Rebecca Solnit, generally a thoughtful and eloquent ally to the broad spectrum of the Occupy movement, falls into a binaristic "ideologeme of the right" (as Jameson describes the concept of terrorism in its legitimization of neoliberal "democracy" as nonviolence). Here, Solnit's primary example of CrimethInc's "violent" tactics is the events of the evening of November 2, 2011 following the General Strike in Oakland. In the course of this action, The Travellers Aid Society Building, a structure that once housed social services (now defunded), was occupied and proposed as a self-managed site for mutual aid and prefigurative politics. In a thoughtful statement, the participants describe the action and response as an act of mutual aid that was attacked by the police with needless brutality (See Appendix C). Having attended this occupation, I can confirm that this was an accurate description of the goals and response to the event (see Isaacson and Paschal). Additionally, previous to the strong police reaction there was a joyous and prefigurative dance party that built on a tradition of "electro-communism" which had been a productive tactic in the Bay Area since the University protests of 2009. Yet, despite all this, in Solnit's description the event was reduced to a kind of activity that was equated with state violence. For Solnit, the mentality behind black bloc tactics is uniform and personified by CrimethInc, which she calls privileged "empty machismo peppered with insults" (Solnit, "Throwing"). This reductive analysis of a thoughtful, organized, diverse event highlights the way that blanket criticism of the black bloc limits the epistemological

horizons of such crucial events as the Occupy movement.

The discourse of maturity and childishness was widespread during the Occupy movement, with Oakland Mayor Jean Quan accusing the protesters of having tantrums and using the city as their playground. As Osha Neumann argues:

> Power always represents itself as adult, rational and in control.
> The socially sanctioned definition of what it is to be adult
> includes the ability to be compliant with the self-repression
> required of an obedient and productive member of society.
> Since those of us in opposition have no desire to be obedient
> and less to be productive cogs in the machine, it's no wonder
> we fall into the role of defiant children.

Like Gitlin and Hedges, Quan is a veteran of New Left activism, now taking the role of the adult, scolding the bratty activist-children, "playing childish games, oblivious to the serious real-world consequences of our actions" (Neumann). While there is nothing inherently revolutionary about the category of youth, and indeed, this figure can be seen to have analogous characteristics to a hedonistic stage of commodity capitalism in which consumerism and culture eclipse the serious business of building new social relations, an undialectical critique of youth and political passion is equally analogous to the logic of contemporary capital, especially in the wake of ever more ominous and totalizing waves of austerity which require self-sacrificing "maturity." The rise of austerity as an antagonist should teach us that "maturity" is a central "ideologeme of the right," mobilized to force the global precariat to participate in her own oppression.

Against Authenticity

An analysis of the Occupy movement that neither dismisses nor wholeheartedly embraces its utopianism and youth ele-

ments contrasts the underlying assumptions in both praise and criticism of Occupy's "anarchist roots." The concept of authenticity is a roadblock to understanding the full stakes of Occupy. There is a fundamental epistemological opposition here. On the one hand, an analysis based on pragmatism and authenticity excises the Occupy movement from historicity, and without this context both inflates and belittles its effects. On the other hand, dialectical thought insists that surface reality is in a generative relationship with historical processes, allowing us to complicate our analysis to make room for the possibility of productive failures. The framing of anarchism as a moral and ethical position that shows an aversion to the analytic mode opens the floodgates to simplification, what Theodor Adorno has called "the jargon of authenticity," at the expense of historicization, a logic that can gauge "real openings in the social fabric" (xii).

Although David Graeber eloquently refutes Hedges' evaluation of the black bloc, I think he can also be criticized for his subscription to a kind of fantasy of authenticity. In his valiant efforts to support anarchist creativity and spontaneity, at some points he falls short of historicizing the movement. The leading commentator on and ethnologist of contemporary DiY, Graeber's admirable work has been invaluable in encouraging and documenting contemporary anarchist formations. However, I think there is a lacuna in his framing and by extension, in the self-evaluation of many strains of contemporary anarchism. Rather than looking at the particularly postmodern character of contemporary anarchism and its relationship to precarity, deindustrialization, and the transformation and dwindling of an organized left, at times, Graeber argues for a transhistorical anarchism, making the case for a nebulous category of peasant historical agency by citing this group's intimacy with precapitalist forms of life. Additionally, rather than complicating the relationship of

the artist to the new "creative economy," Graeber tends to privilege bourgeois/artist figures who he sees to be at the forefront of individual development and independence from authoritarian labor structures (*Direct Action* 214). Beginning from these premises, he sees anarchism as a form of organic organization, decision making, and everyday life that is commonly seen in tribal culture:

> Hence anarchism is in no sense a doctrine. It's a movement, a relationship, a process of purification inspiration and experiment. This is its very substance. All that really changed in the 19th century is that some people began to give this process a name. (*Direct Action* 215)

Graeber's stress on continuity underplays anarchism's radically different implications according to its historical and geographical context. In this, Graeber risks eliding radically distinct geopolitical and historical cultures with contemporary anarchist youth culture, which he sees as itself a fluctuating movement between a vision, an attitude, and a set of practices that has no significant relationship to specific anarchist theories, categories, or lineages. In Graeber's framing, the politics of anarchism can be read as transcendent and eternal, an ethical form of pragmatism, and against this I want to historicize the particular forms of anarchism we see in the current movement. It is through this historicization that we can gauge the way contemporary anarchism addresses very specific contemporary circumstances such as consumer culture, deindustrialization, time-space compression, and the feminization of labor.

I want to illuminate another register of anarchist actions in the Occupy movement than that of either Graeber's narration of authenticity or Gitlin, Hedges, Kimaya, and Solnit's narration of pragmatic failure. But this can only be done

through an epistemology that recognizes even uprisings and occupations as forms of expressive negation, or what Madeline Lane-McKinley sees in the Occupy movement as the materialization of political contradiction (*After the 'Post-60s'*). This presupposes an understanding of occupied space as at once "a fulcrum and model for all kinds of social problems and a space of liberation," implying that the stark binary pitting utopianism against practicality, and thus forcing a choice between impossible radical solutions and possible reforms, can be countered with an understanding of the temporary status of utopian formations and the means by which they allow space and time for imagining alternative futurities.

As we have seen above, CrimethInc's definition of play focuses on folk science, the erasure of separation between art and everyday life. This convergence is a helpful diagnostic of the condition of culture as work "on behalf of the dominant organization of life," in the current era. This follows the situationist argument that "realizing poetry means nothing less than simultaneously and inseparably creating events and their language" (Situationist International, "All the Kings"). During the Occupy movement cultural practices underwent a sea change in this direction. Beyond CrimethInc, the generalization of art began to affect artists who previously had not experienced this convergence. This can be seen in Molly Crabapple's self-described transformation from artist to *bricoleur* during Occupy Wall Street. There, as an artist, she found herself with a stark choice, as she describes it, between "freedom or slavery" ("Art after Occupy"). Immediately throwing herself into the thick of it, she began spontaneously generating art in response to specific situations and conflicts rather than crafting it within the confines of a premeditated aesthetic ideology. When ex-Marine Scott Olson was critically injured by Oakland police she drew a poster, "Can You See the New World Through the Tear Gas," which

features a stoic Latina woman waving an elongated American Flag amidst a smoky haze of tear gas. She crafted portraits of protesters in response to media portraits of them as "dirty crazies" ("Movement Story" 20). She made signs for the people's library, general strikes, and unions as the need arose in an attempt to capture the nebulous inchoate something she sensed in Occupy that was "rare and important and fragile" ("Movement Story" 21). As art was created, it immediately entered into circulation without having to go through any specialized channels of ranking or selection. In response to a police raid on the people's library she drew a poster of the Wall Street bull eating books, which immediately became a circulated form of representation in the streets. As Kristin Ross argues, this was also a feature of the 1968 uprisings in Paris, during which artists temporarily escaped from specialization and hierarchy resulting in a moment where forms of cultural production that required much time, resources, and expertise gave way to more ephemeral and immediate forms of artistic techniques (May 68 15). The dismissal of these experiences as meaningless, simply because they ended, shows the flawed logic in "pragmatism."

Transformations such as that experienced by Crabtree imply a criticism of art as a specialized category valued for its isolation from everyday social relationships. This contained creativity is what Herbert Marcuse calls "affirmative culture," one that privatizes the aesthetic relationship, limiting it to the individual imagination and rigorously separating it from social transformation. For the occupiers, struggle and culture are inextricable, and art that would insist on its elevation above political action is revealed to be a way of placating people and discouraging them from engaging in struggle. This issue became particularly apparent in towns known for their specialization in the arts. As queer activist Mattilda Bernstein Sycamore noted in her participation in Occupy

Santa Fe, it became a challenge for her to "unmask the violence" of the town's art and tourism industries, and disrupting "creative" events became a challenge to Occupy's liberal participants:

> The art market in Santa Fe and Santa Fe by extension, is built on colonial exploitation of native artists, cultures, identities, symbolism, land. And now it's expanded to incorporate sixties high art minimalism, pop art, collage, cartoon art, even a little bit of graffiti here and there—whatever sells. (248)

The Occupy movement's hope for an elision of art and practice is often found in culture that harkens back to precapitalist "artisanal crudity." As Michael Taussig argues, rather than serving as authentic forms of art or tools, the makeshift signs created at Occupy became "talismanic" complex signifiers offered, "as a testimony to history finding its articulation in words – words that play with words as much as with history" (76). These talismanic signs were seen as counterpoints to the magic of commodity fetishism and neoliberal myths of freedom in a grand battle over the control of discourse:

> They have pepper spray. We have burning sage. They prohibit microphones. We have the people's microphone. They prohibit tents. We improvise tents that are not tents but what nomads used before North Face. They build buildings higher than Egyptian pyramids, but that allows our drumming to reverberate all the louder and our projections of images and emails at night to be all the more visible and magical, taking advantage of the mega-screens that the facades of these giant buildings provide. (77)

This kind of polarization allows for a simultaneous decentering of capitalist logic and a demonstration of the vast differ-

ence in scale between the two camps and limits of symbolic protest. The talismanic and counter-discursive practices of the Occupy movement represent a simultaneous desire for and impossibility of the smiting of an out-sized Goliath by a microscopic David. However, this ability to name Goliath and to challenge it is a primary step in what is destined to be a protracted struggle.

This understanding of occupation as temporary space of negation and cognition is implicit in Juliana Spahr's poetic framing of Occupy Oakland as "Non Revolution" to signify its status as inaccessible point of desire, its structural impossibility analogized as a love-relationship:

> Our relation was brief. We spent some time together. A few months. Maybe. Perhaps just a few weeks. Depends on how you count it. It happened. It was all fucked. Tongue and hands on clit or cock. Fistfights too. Miscommunication. Constant emergencies. It unhappened. Text after text. Then it happened again. Tongue and hands. Also injuries. Illnesses. More miscommunication. Status updates. Deep emotional confusion. It was all good. Hand in hand. Exuberant, giggling desire. Then it unhappened again. And still, joy. Laughter. Care. Almost psychedelic. A feeling that at moments hinted at rivers running backwards. A flooding in other words. Wind and rain and hatred of capitalism with tongue on tongue. Stuff like that. Happening. All fucked. Unhappening. All good. And also, happening. All good. Unhappening. All fucked.

In this vision of "non-revolution," "non" does not neutralize "revolution." Instead there is space for a simultaneity of exuberance, "giggling desire" and all that which is fucked, that which is happening and that which is unhappening as the speaker navigates revolutionary desire and its material containments as she remaps a city comprised by a "totality of

sensory and emotional affects," as McKenzie Wark describes the situationist project (Beach 20).

Through a Utopian Spatiality, Blackly

The black bloc developed in the Eighties from German Autonomous squats and other radical collective houses that were the sites of everyday life as well as political planning and debate. To support the everyday needs of these groups, a large number of self-managed institutions developed, which George Katsiaficas notes grew to affect 80,000 to 100,000 people (102). The benefit of asserting physical self-managed projects rather than participating in abstract organizations could be seen in the autonomous women's movement, which never had a major organization yet was one of the most effective in the world. Adopting models from consciousness raising groups, German feminist autonomists eventually erected dozens of women's centers that sponsored bars, newspapers, magazines, and cultural events, without recourse to centralized organization (Katsiaficas 71). Against the stereotype of black bloc tactics as masculine and implicitly sexist, this feminist influence was central to the forms autonomy took.

The US version of the black bloc builds on this model, attempting to spontaneously seize space through insurrection or self-management, as a mode of fighting against global economic forces. The black bloc uses a variety of tactics; it is not a formal or continuous organization, acting rather as a "temporary cohesive grouping with the immediate goal of creating a temporally contingent street fighting force." The group has been a strong presence, with from 100 to 1000 people participating in most of the economic summits and large anti-war protests since The Battle of Seattle in 1999.

The black bloc strives to make abstract ideas about state violence and capitalist contradictions concrete by bringing them to the streets, forcing contestation and baring the

repressive core of seemingly benevolent forms of authority while exceeding spectacular and reified forms of moving through the city (Van Deusen 12). Predictable demonstrations are seen by the group as a "social pressure valve," and the black bloc seek to exceed these sanctioned forms. This type of spontaneous leaderless group also operates as a prefiguration of self-management as it navigates spaces without the sanction of police or government. "The city, in the vicinity of conflict, truly becomes the people's to be won, lost, held or discarded" (Van Deusen 12).

Black bloc tactics point to the duality of prefigurative spatial utopianism and cognitive mapping that is the heart of the Occupy movement in response to a late capitalist "shifting of the temporal center of gravity to a spatial one" (Jameson, *Valences* 68). As Fredric Jameson argues, contemporary social organization revolves around the displacement of production, which creates a duality of underdeveloped and overdeveloped space, the latter characterized by services, restructuration around consumption, advertising, and image society; "in other words an emergence of commodification as a fundamental social and political issue" (*Valences* 68). This displacement of production and lack of national autonomy leads to a dominance of spatial concerns over the traditional focus on temporality. For these reasons, in order to be self-conscious, it's necessary to foreground homologies of space and to see spatial fields as allegorical. The tactic of occupation at once facilitates this allegorical view of local space and enacts a prefigurative transformation of these temporary autonomous zones.

In my interview with Occupy Oakland participant Roman (Appendix B), he describes Frank Okinawa Square, which was renamed Oscar Grant Square by the protestors, as a transformed space. Having spent time in the Square before the occupation, he saw it as "really sterile, empty and heavily reg-

ulated." The emptiness of the space and the anonymity of the surrounding building distorted its size, making it feel overly large and barren, and while he would sometimes hang out there, there were few people to talk to and no reason to talk to those who were around. He notes that during the occupation the space seemed to change, to shrink and to feel like a busy populous "city within the city." He describes the space as a counterpoint to the sprawling suburban, ex-urban, and gentrified spaces of Oakland, one where people could mingle with others outside their social sphere and class. Rather than describe Occupy Oakland as a set of pragmatic tactics, he implied that this was a *détournement* of "fixed space," to open up its hidden potentialities and social relations (See Appendix A for my interview with Agnes Rivers and Sophie Valentine on the dynamics and desires at stake in Oakland anarchist squat culture that supported the Occupy movement.)

These utopian dimensions of Occupy's spatial practice are generally qualified by critique from within the movement as well as from public commentators. The Occupy movement could not escape a world of generalized racial oppression, gender harassment, and homophobia. In some ways, without the established forms of societal mediation in place, these violent social relations got worse. However, in testimonial after testimonial, participants noted that it was important to distinguish this failure to transcend a larger troubled society from the utopian, transformative experiences that were also part and parcel with the events.

A "pragmatic" view of the Occupy movement that forces us to choose only one of these perspectives betrays the evident complexity of Occupy-related experiences and narratives. For instance, Occupy Baltimore participant Koala Largess noted that even though she didn't always feel safe in the encampment, she felt that grappling with seeming impasses created openings and emergent forms of communication:

> We had come to build a future and we all had a job to do on that
> construction... My lesson from the dysfunctionality of occupy
> is that we need to learn from others and from less than ideal
> experiences to be part of a stronger future. In sharing space
> and working with people who are not of the same perspective,
> we begin to prefigure our world. (Largess 307)

Manissa McCleave Maharawal draws similar conclu-
sions from a contentious moment in the general assembly
of Occupy Wall Street, in which she and some other South
Asian friends challenged a line in a proposed declaration of
Occupy Wall Street that qualified the group as: "one people,
formerly divided by the color of our skin, gender, sexual ori-
entation, religion or lack thereof, political party and cultural
background" (175). For Manissa and her friends this utopian
erasure of difference ignored and simplified a long history of
colonialism. Defying what they saw as false unity and against
some resistance from the larger group, Manissa's group got
the line stricken from the declaration. Thus, the closures and
impasses made evident by Occupy gave rise to new openings:

> In that small circle following the assembly we offered a
> crash course on white privilege, structural racism, and
> oppression. We did a course on history and the declaration of
> independence and colonialism and slavery. It was real. It was
> hard. It hurt. But people listened. Sitting there on a street
> corner in the financial district talking with twenty people,
> mostly white men, it all felt worth it. Explaining the way that
> women of color like me experience the world, and the power
> relations, inequalities and oppressions that govern the world,
> felt for me like a victory... and like a victory not only for
> myself and others who feel the way I do but a victory for the
> movement. (175)

Some parents experienced these limits of Occupy as a form of "adventurist machismo," excluding families. Says then new-mother Madeline Lane-McKinley:

> To participate, one must be arrestable, and arrests must be affordable: one must have the funds, the spare time, the freedom from responsibilities. Ultimately, the arrestable are those who represent the movement. They speak of the movement as what "we are doing," as if to address a *you* who is *not doing*. ("And We Mother Them")

At the same time, this "failure," led to new awareness of and collectivity with other women in this marginal position as a means to "materialize solidarity." These spatial formations allow for the imaginary of enduring communities. Protests are generally punctual events, but tents and encampments served as "manifestations of a long term resolve." An Occupy movement St. Louis flyer demonstrates this duality of the movement as everyday practice and symbolism:

> The occupation of this building is an act against the structural violence entrenched in our political, economic and social systems. As we move into the space, our intention is to collectively re-invent its use. We're trying to discover ways of interacting with each other as equals. How to talk so everyone is heard, how to make decisions so everyone's considered and included; how to feed and maintain a shared space; how to make sure work, responsibility, pleasure and ownership don't fall on some more than others. It's a hard process in itself but it's made even harder by the fact that it flies in the face of how almost everything in this city (the whole world practically) is run...We carry a new world in our hearts, one much more fantastic, more empowering, and more just than the current one. (Anon., "Text from a flier")

Bernard E. Harcourt describes this everyday, spatial focus as "political disobedience" as opposed to civil disobedience, defining the former term as an encompassing resistance to government by refusing to accept sanctions by the legal and political system, partisan politics, policy reform, or party identification and rather staging democratic gatherings and occupations of public space (34). In this framing, even speaking about Occupy from an outside position belies this refusal: "Normative statements about Occupy Wall Street – claims about what the movement should do – are functionally inaudible unless the speaker is physically occupying an occupation" (44). This spatiality is theorized by Ontario anarchists, who see contradiction and complexity in every moment and relation of Occupy Vancouver, but argue that the sharing of social space makes these contradictions productive:

> What makes this occupation a real event of thinking and
> acting is the engagement with these complexities within an
> open political space. In these rendezvous of various forms of
> life and ideas, a plane of consistency is constructed. This plane
> is the site where relations are intensified between a common,
> and our differences are developed. (D. 87)

Occupy Wall Street did not merely occupy space but traced power and control as it manifests in ostensibly public space:

> Its location, design and construction limned the legal, juridical
> and police affordances of New York's public realm, revealing
> the constraints placed on people assembling to form a counter-
> public – a public operating according to practices distinct from
> those of the mainstream. (D. 29)

Yet this freedom was circumscribed by police control in the form of "order maintenance policing", allowing the NYPD to intervene in public events even when all behavior was legal. The Wall Street occupation took advantage of the lags and ambiguities of the POPS system (Privately Owned Public Space), "which has created places where the city government must negotiate authority with corporate owners as well as site occupants", allowing for a rewriting of social and spatial codes and creating semi-autonomous forms of governance and provision of services, art, and recreation (Massey and Snyder). However, this prefiguration could only map contemporary spatial impasse; transcendence was always temporary and fleeting, as true public space was always belied by state and private control.

This need for the foregrounding of space is made evident in an open letter by activists in Detroit (Appendix D). It is clear to them that occupation represents the unique hopes and problems of Detroit, and the city itself is a means to concretize broader economic questions. Occupy Detroit is part of a lineage of social movements such as the League of Black Revolutionary Workers and the current poor people's campaigns, and also of hardships particular to Detroit as the nation's most dramatically deindustrialized city, site of white and middle class flight and crumbling infrastructure (Brown et al. 86). Jameson's argument for "cognitive mapping" itself focuses on Detroit and the League of Black Revolutionary Workers as a central site of resistance and contradiction, but also sees local uprisings as necessarily curtailed by the limits of "the society of the spectacle." As soon as key revolutionaries tried to generalize the struggle in Detroit, they instead became media figures, who themselves figured the ways a global culture industry converts activity into passive images. Thus, as the Occupy Detroit movement implies, an account of Detroit that comprehends the role of mediation can gen-

erate a specific and complex understanding of the gains and losses in the movement, rather than simply seeing the Occupy movement in the binaristic terms of success or a failure.

Ludic Limits

Despite these important utopian dimensions of pro-Situ, black bloc activities, when these forms of politics do not engage in self-criticism and historicize their own limits, they become symptomatic of "capitalist realism." The utopian view of Occupy politics must be balanced, not by pragmatism, but by a critical realism. Insurrectionary strains of militancy can converge with theoretical tendencies that display what Benjamin Noys calls a "disregard for the forms of state and capitalist power" in favor of "life," and this dismissal comes at the price of flattening and reducing the complexities of contemporary political economy ("Recirculation"). As Sasha X argues, the Occupy movement in some regards imitates and maps a generalized abjection and crisis, forming a mirror to the proliferating "tent city" in our present condition, what Mike Davis calls "the planet of slums." In the face of the full subsumption of the globe under capital and the becoming-superfluous of many forms of labor, the Occupy Movement can be said to map what X calls the "common abject." This is another aspect of the spatialization of Occupy; it can serve as a corollary to a political-aesthetic logic of the politics of disaster and exclusion, foregrounding "the aesthetic through which the movement reproduces its own figuration" ("Occupy Nothing").

Occupy's constraints map onto the problem of contemporary "landscapes of power," as counter-culture contestation is always susceptible to absorption by a capitalist city which must operate as both a site of what Sharon Zukin argues is a "cultural hegemony of economic power and an image of social diversity" (Zukin 180). The city is an ongoing con-

structed social relationship, a problematic relation between use and value, and a cultural process which projects like DiY can participate in critically and complicitly at once. An ongoing dimension of the construction of the capitalist city is "creativity" and neo-bohemianism as a form of "colonization by the marketing of culture" (Zukin 186). The very creative and cultural dimensions that mark Occupy's sense of futurity mark its point of absorption into contemporary landscapes of power and bare the ideological dimension of what Greg Sharzer sees as localist fantasies or "Proudhonian fantasies of artisanal production" (Sharzer 57). As CrimethInc reminds us, all kinds of right-wing groups can and do employ decentralized formations, speculating:

> The 20th century taught us the consequences of using hierarchical means to pursue supposedly non-hierarchical ends. The 21st century may show us how supposedly non-hierarchical means can produce hierarchical ends. ("Fighting in the New Terrain")

An anti-capitalist realism cannot uniformly condemn or laud DiY, but may point to and try to augment its diagnostic elements and put itself at the disposal of struggle and an expanded radical imaginary.

Conclusion

CrimethInc and related tacticians in the Occupy movement should not be viewed reductively. In concert with a range of other approaches, these instances of cobbling together public spaces and ways of living represent a moment of global politicization, contributing to a long history of radical resistance, and helping to imagine another world in the face of a repressive "planet of slums." We must not rely on fragmented assessments of surface events to analyze the

meaning and direction of these movements. By looking at Occupy in the context of its historical conditions and by trying to understand the motivations and political orientation of participants beyond specific protests and events, we resist narratives of failure and defeat and remain supple and tactical in our hopes for radical politicization. The concept of expressive negation and the recognition of the impasses faced by youth-oriented factions of the Occupy movement allow for an important intervention in historicization. As CrimethInc argues, it is easy to form solidarity around loss and martyrdom; it is more difficult to generously engage with the hope for collective joy:

> As many hardships as it may entail, our struggle is a pursuit of joy – to be more precise, it is a way of generating new forms of joy. If we lose sight of this, no one else will join us, nor should they. *Enjoying ourselves* is not simply something we must do to be strategic, to win recruits; it is an infallible indication of whether or not we have anything to offer. ("Fighting in the New Terrain")

Anti-capitalist gestures and hopes deserve anti-capitalist analyses that don't fall into the easy neoliberal rhetoric of "maturity" and "realism," and instead stay open to what Hunter Bivens sees in the literature of commitment during periods of closure, "a 'we' under erasure" (12). The rhetoric of immaturity has come back in force with reaction to anti-austerity movements in Greece, Spain, and elsewhere, with such infantilizing tactics as that of Christine Lagarde, president of the IMF, demanding, during negotiations with Greece, to speak to "the adults in the room." This discursive infantilization of struggle is part and parcel of a long legacy that bridges colonialism and neo-colonialism, as entire nations are economically conquered in the name of "civilizing missions" to

control supposedly child-like peoples (Marder). Instead of supporting these dichotomies between youth and maturity, we must analyze characteristic "youth movements" with what Ernst Bloch calls "militant hope," keeping alive alternative logics and potentialities.

Appendix A

Interview with Agnes Rivers Valentine and Sophia Valentine

Johanna Isaacson: Tell me a little about the squat. Is it called the Hot Mess? When did you start living there?

Agnes Rivers Valentine: The Hot Mess started two and a half years ago and the RCA, which is on the same property, was also 2 years ago. I moved there at the end of 2011.

JI: What made you decide to move in there?

AV: Just knowing that I wanted to squat. I'd hang out around there and I really thought the space was amazing and unique. And it was free!

JI: Did you know how to work on building before you moved there or did you just learn on the job?

AV: The shack that I built there was the first thing I built but I knew a little about construction before. I definitely have this memory of going to the lending library to get a snake with my other best friend who I moved in there with and checking it out and getting to the point where we're going to go and then thinking maybe we should check out a book on plumbing. We did it in one day.

Sophia Valentine: I remember you guys telling me about taking out the trash under the sink. The sink just exploded and water came up.

JI: Did you have utilities and water before that day?

AV: There wasn't running water in that house, which is what we call the RCA, which is an apartment building right above an old RCA TV repair studio. That place had running water but nobody had fixed a sink yet and there was no bathroom sink so we fixed the sink and put in a bathroom sink.

JI: Did you ever get too grossed out by your living quarters?

SV: Yes. So often.

JI: Because I remember my brother lived in the squat called the Bat Cave and I just remember the toilets really smelled awful.

SV: One thing that motivated me to fix a sink was that it was just right when Occupy was starting, and for me it made so much sense for us to have meetings at the RCA but I overheard someone say, "We can't have a meeting there. That place stinks so bad, it's so gross." And my heart broke. I was thinking it was more important for me to snake the sink and fix the faucets than anything in Occupy.

JI: Did it become a center for meetings?

SV: I think it was a really important space and I think that being in an environment like a squat you can sort of imagine yourself taking risks differently than in the way that you normally would in a place that was rented. If you're angry it's not really a big deal if you slam a hammer into a wall for example. So I think that a lot of that was really important, whether it was banner making or meetings. It's a huge space so we had more space than most houses could offer.

JI: Did you feel like you learned ways to make the plaza work from squatting?

SV: The thing that I have learned most from both squatting and being in the plaza was that I was able to relate to people who I wasn't normally friends with or wouldn't normally be friends with. The plaza was a really friendly space so we would do things together that you wouldn't normally do with a stranger and there was an amazing breakdown of public and private and between stranger and friend. A lot became possible at that space. We ended up getting to know a lot of our neighbors and really getting along with them, with some of them moving in. These were people I wouldn't normally ask to be my roommate whether because they couldn't afford it, because we listen to different music, or whatever ways in which we break down. It wouldn't normally make sense for me to move in with this person but in the squat it was really easier for us to live with people who were different than

us and then through cohabitation, eating together, living in the plaza, whatever, different relations were able to break out of these new kind of interactions.

JI: Yeah I interviewed somebody else who said the exact same thing. Did you ever feel like when you brought someone into the squat that there were difficult boundary negotiations?

AV: Yeah, yeah, boundary negotiations are a constant thing. There are people coming from very, very different places in life, well versed in radical politics and identity politics and rhetoric and some not at all, so that's always challenging to try and communicate in the same language. But because you are all staying together you're able to develop new languages to communicate those ideas.

JI: Wasn't it during Occupy that you were threatened with being closed down?

AV: It was actually about a year later that that happened. We actually got our first action letter on the one year anniversary of Occupy.

JI: Okay, so it was really recent. So I remember seeing celebratory stuff, but I didn't understand the whole struggle. Was it really a big process and how did you do it?

AV: It was quite a saga to rival all sagas. The greatest story ever told. Just about a year ago we got served with the lawsuit by this real estate company that had bought that building on auction. They were serving us with this thing called forceful detainer, which gets people out really fast and is supposed to only take a couple months. We got served in July and then we just continued to file permissions to overturn the ruling. We really spent a lot of time on it. We were a bunch of punks that hung out at the law library.

JI: So you did it yourself?

AV: Yeah we had one person help us, an intern. But we were doing all the writing ourselves, doing all the research. We figured out that it didn't actually apply to us because of these legal stipula-

tions and we kept telling the judge that and the judge kept ignoring it, kicking the can because obviously, why would you rule in favor a bunch of squatters over a real estate company? But six months after that we finally won.

JI: So how much time did you have to put into this? Was it a full time job?

AV: Yes, full time.

JI: It seems like you have a lot of chores. How much time do you think you spent working on the RCA during the week?

AV: It's an interesting process. You definitely have 10 more steps to your day before you even, I have to be frank, take a shit and make coffee like a normal person does. So sometimes it's hard because it's completely inventing new habits which incorporate maintaining a property and friends and animals and yourself and so it can be a full time job. It can also be just like, I want to say a lifestyle, a way of living 24/7.

JI: Yeah it sounds like you can't really call it work in the way that we understand work. You're doing it with your friends and you don't have to go to some office with random people so it might be kind of hard but it's not exactly work. This is the sort of a thing that I was interested in in getting into DiY. You can't really use those categories anymore like work and play. It's like you guys were saying about friendship and people who were outside the friendship circles. These definitions only arrive from these situations.

AV: Exactly. I'm really fascinated by it for that reason, because it's the only place that those things can happen.

JI: So was this part of your decision to get involved? Did you try other jobs and you felt like you were ready to make this dramatic step? Or was it a dramatic step?

AV: I would say the experience was more dramatic than I anticipated it being because of the eviction things and all the things I experienced.

JI: How old were you guys when you started to squat?

AV: I was 24.

SV: It was my 25th birthday when I moved in the RCA. For me it was sort of seamless to move into the squat because Agnes and our other best friend was there too, so of course we're going to try this thing together. I had stayed in places like this in Barcelona, Bloomington, and in other towns. I've been in squats for different periods of times and so I wouldn't say that lifestyle change isn't why I got involved, but it was definitely why I stayed and within the first month I was like wow, this is what I want, just to work on this collective project with people and also to work on my own creative projects. This period has been the juiciest in terms of my creative output. This is something we would talk about a lot during the beginning when we were going to these different squat defense things. We would always stress that they can't have our time. Even if they win it won't matter because they can't get this time back and in that time we did these amazing things. We were creative. We made meals, murals, we played music in the back-yard, we hosted events.

JI: Yeah I remember I talked to you yesterday and you said you were at band practice. Were you doing music and art before you squatted, or is the squatting period what inspired the creativity?

AV: I think we both had always done creative things but we definitely went through this really intensely vibrant, I would say, renaissance. We were just in the space and all of our time was ours. This still makes it meaningful to me and makes it worth it even when you look at it on paper, the time you spend is pretty much equivalent to a job. But it's not a job. I'm extracting the benefit of the work I do. I'm not working for a job that I have to wait to get paid but then what I do doesn't affect me at all. No, if I want to shit I have to figure out how to fix a toilet and that time is worth it because I get to take a shit and so on and so forth, and everything I do is for the direct benefit of the life of yourself and the people around you.

JI: Do you feel like you have a network of people who support your creative projects?

SV: Yes and we've put on a lot of music events in the downstairs area. That's always felt really good. There's been a bunch of shows that were either benefits for something or an after party for different big events. It always fills my heart so much to see our friends out there in front of the "dump your landlord" banner, playing a show.

JI: So when people need money do you feel like you are able to raise it through events like that? Like if somebody needs bail or medical care? Do you think that system is working pretty well?

AV: We raised a hell of a lot of money at that place. Our friend had heart surgery. I mean I think that event raised almost two grand or something. It's pretty streamlined. People can bring food to contribute. And you only have to pay if you can.

JI: Did you worry about the lack of structure to your time? It seems we're trained to be really passive people. It sounds like it wasn't that hard of a transition for you.

SV: Well when I moved into the squat I had lived here for quite a number of years, and so I had a certain regiment to my life that didn't cease to exist even though I didn't have to work as much I still had the same job. So half of my life was normal and half of my life was totally completely different. There were times when that gave me anxiety but for the most part there wasn't really time to stop and think.

AV: I definitely see people in the space struggle with that.

SV: That's true.

JI: So your parents, what do they think?

AV: I held out telling my parents for quite a while. I finally told them right around the most intense part of the RCA eviction drama because it was so consuming and such a huge part of my life. And you know, I'll give it to them, they took it really well.

JI: Really, what did they say?

AV: I definitely think that they're extremely liberal and they're like "do good unto others." So it helped that our house has held benefits to raise money, it helped that our house was abandoned for a really, really, really long time before we moved into it, it helped that we have a free store. I think this situation would have been different if they couldn't understand these good things. Actually they're pretty proud of me.

JI: Did they suspect before you told them?

AV: Well, they realized the math doesn't compute. How do you survive without having a structured job? I would just glaze over everything. I would tell them about the house minus the squatting: that we have gardens and chickens and it's huge and tons of people and it's crazy.

JI: Sophia, I think you said before that your dad had himself kind of given up certain kinds of striving or ambition and he influenced you to do that in some ways?

SV: Definitely, I feel like I didn't have to grow up with that sense of "strive to succeed," "be everything I want to be," all the cheesy ways that teenagers are drilled in the 20th century. I didn't have to worry about that. I knew that I was a total freak and I feel really privileged to have known that. So this is no surprise to anyone. My family knew about it and this was just another notch on my weirdo belt.

JI: That's awesome. Now of course I'm going to ask about the gender politics in the house. Has it been a big issue or has it not?

AV: Identity politics is always a thing that comes up.

JI: What do you mean by that?

AV: There's always been a lot of different marginalized groups in the squat. The Hot Mess started as a safe space for queer and trans people and then over time people from Oakland, people of color, and you know all these different types of folks were coming to live together. So dealing with that whole dynamic... It definitely seemed to get male heavy, not necessarily in a terrible way, just for a while there. It just seems like men were more open to it.

Right now there's a pretty good balance.

JI: When you say it started as a queer safe space what do you mean by that?

AV: Well I wasn't there so I don't know their intentions and decisions. That was a place where gender queer and trans folk could live without having to deal with any of the bullshit that they have to deal with stepping out in the street.

JI: I know that feminism is a problematic term, but how would you define yourself in relation to gender politics before and during living in the RCA?

SV: Everyone who knows me knows that I have a very tenuous relationship to the word feminism. Feminism is something that I'm always pushing against the wall of and pushing the boundaries of and trying to figure out how to approach feminism with the aim of abolishing gender being its first goal and not its last goal, and so I'm constantly encountering its limits in pushing those boundaries. That said, this summer I'm realizing how women are just better at everything. All the boys went away train hopping all summer and everything is happening that needed to happen like six months ago because there's mostly not dudes in the space.

JI: Do you (Agnes) agree with that?

AV: Yes, things that needed to are getting fixed and the bills are getting paid. There's more attention to the basic necessities instead of lounging in the court and getting drunk by five, which is what a lot of the boys who live there do.

JI: Do you feel like part of that competence and being able to do everything is that you've subjectively achieved that goal of subverting the gender binary? Do you agree with Sophia that you want to abolish the gender binary?

AV: I do. I think it's hard to ignore the trends within the house along the gender lines. But I don't feel like my place is troubled. I mean I'm treated with respect. It has nothing to do with gender. And I give that respect to the others as well. I don't experience

much if any sexism. Historically, it's been a question over and over for us I guess because of this, because I think what you (Sophia) were touching on as identity politics always being a part of the space. People have used gender as an excuse to get their way basically, or as a sort of verbal short cut towards having their needs met. So people have just... it's a term we call "squatting the squat". People stay forever without going to meetings or becoming housemates.

JI: Do you have an agreed set of guidelines that allows you to live at the squat?

AV: Yes but people who want to stay have often used calling all the men male supremacist or white supremacist males, or patriarchs or manarchists or fascists, in order to disprove that those men were saying something somewhat rational or legitimate, which is: well, you didn't go through this and this process. Or you've been asked to leave and you're refusing and that's making us feel uncomfortable.

SV: That's the way gender politics works for me, because no one wants to be the woman at the meeting saying, well, that's not the way that gender really works. Because that's awkward.

JI: That's interesting. I've noticed that there's a weird inability to have accountability. It leaves you unsettled. It gets abstract. But what are the things you have to commit to in order to live there?

AV: Oftentimes people end up living there because they're a friend of a friend. It's not very often that a traveler will come through, stay for a while, and get involved enough that they want to stay. I can't think of many examples of that. So they have to go to meetings, because we have consensus based decisions, and see how people feel about it. But if everyone agrees, there's no blocks, but that's not really an issue. The issue is that people come to the space, stay forever, and use rhetoric to shut people down so that they can get their way if that happens.

JI: And what about relationships? Are there people in monoga-

mous relationships or is there a philosophy that's shared in what you're looking for in egalitarian relationships?

AV: In our space it's all over the board. It's not really agreed upon. There's some people, like the neighbors who moved in, who have been together for 15 years. And then there's a broad range of radicalness in that mentality.

JI: So it's all accepted. Are there exes and tension around that?

AV: There hasn't been that much inter-house mingling that creates tensions.

JI: How many people live there?

AV: It ranges. Now we're at like 10. Last summer it was 40.

JI: Do you have a shower?

AV: No

JI: So what do people do?

AV: Smell

JI: Do you have a Food Not Bombs that makes food there?

AV: Food Not Bombs brings us their leftovers but there's only so much hummus and leftover tofu you can eat.

JI: Is most of the household vegetarian?

AV: No.

SV: There have been known to be several fish fries.

JI: Do people have their own private food supply?

AV: Not much there is sacred, so if you want to keep something you keep it in your room.

SV: There seems to be at least a small majority who live off food stamps, getting food from the corner liquor store.

AV: And eggs from the chickens and vegetables from the garden.

JI: How did the garden start?

AV: It's been evolving since the beginning of the squat, just because people were into it.

SV: Yeah, the back yard is like a half an acre. And when they first moved in it was a big grassy meadow with long tall grass, and now it has two shacks, a fig tree, a redwood tree that's like 100 years

old, a chicken coop, a greenhouse vegetable garden, an herb spiral, several different herbs and vegetables, and a fire pit with homemade benches around it.

AV: And occasionally there is a propane shower that sometimes works.

SV: But oh when it works its glorious. It's surrounded by blackberry brambles and on a sunny day it's just the right thing, but it rarely works because fuses and wet things don't go well together.

JI: And you, Sophia, you've studied plants. Did you do that independently or did you do that through school?

SV: Oh both. I did career enhancement classes at the community college but I'm a gardener by trade.

JI: So you do little part time things and that's mostly self-taught through supplemental classes and you can make your own hours… And Agnes what do you do for money?

AV: My way that I make money is through interior design. I get random jobs like twice a year, and that combined with other jobs is enough.

JI: How much money would you say you needed to survive?

AV: I think I lived off $6000 last year

SV: Last year my tax form said I lived on $4000, but I had a few other things under the table.

JI: Wow. Do you do anything to spread the practice of squatting, knowledge, and tools?

AV: Well, last year there was this feverish pitch for squatting. There were a number of squats and we'd gather for what we called "squatlucks" and we had lots of different projects. Some people started a squatting hotline and people could call in with questions and there were people around the Bay who gave tutorials.

SV: People came through and have different events. Like the eviction process first started, Agnes and I got really into reading *The Subversion of Politics*, not that we agreed with it all. We were just sort of like trying to extrapolate from other peoples' experience, little things that people could take away. So there

was a time where The Subversion of Politics was on the table all the time. We had a squat defense thing one time where we read some of that out loud and then led a discussion about it. But she watched every squat documentary ever made and put them into a photomontage. So, I feel like there was this time when we were really kind of trying to figure out what this thing was that we were doing in a really intentional way, and arriving in a place really slowly. I feel like when you come to a place you're up against lethargy and alcoholism and laziness and that is just a given that that is going to be there. And arriving and saying okay, we're going to be like the autonomists, is really counter-productive. The way that it really worked in our favor is that we had this show space and we could do things so that we could build trust together slowly. And the benefits weren't easy but we did them together and they made money and they worked. That, paired with our studying of European squatter movements, was a good thing, and that was the time that there was feverish activity around the eviction. It was the squatting summer where we were talking about putting up spaces that were just for specific activities or just community cafes, and things like that.

AV: And farms.

JI: You're talking about the Katsiaficas book, right? Because he was saying that these spaces were institutions. They were projects at the center of things.

SV: And that has to be... there has to be a central project that you're all invested in and you all have to arrive at that together slowly. I think that was also true with Occupy. All vanguards were really unsuccessful in organizing the populace. And what was more effective was this slow coming together and melding of everyone's ideas.

JI: It seems like there's this tension in building projects... to have this group that's stable and that's building something and to bring in new people and try to relate to them. Do you think RCA is better at one thing or another? Do you think it's developing into a

stable thing or do you think it's more about bringing in new people and learning ways to relate to them. Or is it both?

AV: I would say it's both. The last year has been just kind of an evolution, a regression at times. The eviction did have everyone together and galvanized the comradery and did make it easy to feel the intensity and urgency of being directly confrontational with the powers that be. That was exhausting and the constant threat of repression for six months is something that drove almost everyone near to insanity. Then the spring was kind of this healing process where everyone had to draw back. And this summer it's like we still have this space. What are we going to do with this? What does it mean to everyone who came to paint banners to protect it? But now we're just like not as involved in it in a day-to-day basis. So our project for this summer is there's one extra room in the downstairs area where there's an event space and we're going to turn it into an infoshop and a community apothecary.

JI: So you guys are drawing up plans to get that underway?

AV: Yeah on the 19th we're going to have a big benefit fundraiser because it's going to cost them money to fix the plumbing in there so there's a toilet. And it's in pretty bad shape because the room was left empty for 20 plus years. Well, not empty, full of shit.

SV: It was a hat shop. Full of sewing machines, hats that are rusted and that kind of thing.

AV: It was weird to take it apart because it's a time capsule from people we don't know from decades ago.

JI: I talked to Sophia about the ways she had an explosion of creativity once she started squatting. How would you qualify your explosion of creativity? What kind of art do you do?

AV: Drawing. I had time to do that and inspiration to do that. Everything around me felt more exciting and more possible. It was a time where we felt we could do anything. Whether that was true… You know I think it had a lot to do with us being in the space. Taking our time back. It was definitely formative.

From creativity to learning how to do legal work. It's been an interesting experience.

JI: Do you worry about... if you decide to do this for your whole life about health things? It does seem like there should be some kind of health collective. I had a friend who was a young anarchist who got lymphoid cancer when she was 22 and we were able to help her get through it. It sounds like you were able to help your friend who had heart surgery. And you wonder about retirement communities. Punk retirement. And what motivated your (Sophia's) choice to live in a smaller place? Did you want more privacy?

SV: There was a lot of things. Some of them were basic external factors, like my dog getting sick. Squatting was totally unpredictable and I thought if I trimmed the fat and I changed the way that my basic needs were met I would have more time for revolutionary activity and creativity. And it worked. Sometimes you just need to shuffle things around and then you can reconcentrate your energy and that's what happened. And now I feel like I can make minimal commitments to specific things whereas before I felt like I was doing everything and doing nothing.

JI: Do you (Agnes) ever feel like that in the space, that it's hard to figure out which projects you are going to focus on?

AV: When you live there that's your project, and that's what almost took me away from the space before is that I feel like I would like time to focus on other projects. But so far I feel like it's still fascinating and exciting enough that I'm not quite ready to leave.

JI: You (Sophia) said you visited a squat in Spain?

SV: And in Greece and in Mexico and in Italy and in Turkey.

JI: So whenever you get to travel you go on squat tours?

SV: I've travelled very little but I've only travelled while excited about squats. When I was volunteering at an infoshop in Santa Rosa my favorite book was about Louise Michel. My interest

went back to the Paris Commune. I've always been fascinated by having something that's worth defending, and that not being some superficial thing but something that you have built with others. And in the process of creating it you've organically formed this drive to defend it and that is definitely how I felt there around eviction time. It was like, I have to defend this space because I remember when we did this thing or this thing and it was really special.

JI: I feel like I've grilled you for a while. I'll turn this off unless you have anything you want to add.

SV: You guys were talking about the apothecary and the importance of the apothecary and I wanted to say something about that. I think that chaos is a really beautiful thing and that there has been around the formation of the squat the chaos of excitement and adventure. But I do think it's good that things are taking a more wholesome turn and that we are building apothecaries and things like that. We jumped into a lot of commitments that we weren't able to finish our end of and in that way it turned out heartbreaking. Like in the case of a woman who moved from Oakland who had a pretty fierce drinking problem and had lived on the streets for a really long time and so was unhealthy and was also an older woman. And her behavior was quite erratic but we all loved her so much and she was a really good friend for all of the house and she became a little bit healthier for being able to live there and having a stable place to cook food. But people gave up on her too soon before they tried to take care of her and help her and make her soup so she didn't have to eat whatever was lying around. And the atmosphere was such that she maybe drank more than she would normally because the lifestyle was like that around then. And she eventually was punished and shamed and left and as far as I can tell punishment is always wrong or it's never right to punish anybody. I saw that in Occupy too. There were different forms of punishment that happened. Or people were asked to

leave and what actually worked better was feeding them three times a day and having direct ways of communicating with them. There was one guy who had problems and one day he flew off the handle and someone took a two by four and whacked him with it. And in a few days he came back and said I am so sorry. I have been such a pain in the ass. And he just started helping with cooking and now he's somebody that the anti-repression crew does a lot of work with because he got arrested. Because having all these different characters in such a small place means that a number of them are going to be pretty crazy and personalities are going to be pretty hard, and I think finding ways to incorporate those personalities is one of the most important social projects.

JI: Do you get a lot of push back when you make those arguments?

SV: I think a lot more people are ready to live this way than do. And it always comes back to this question of how are we socialized to live a certain way? That's the most challenging thing of any social project I've ever done is watching people be punished and excommunicated when there weren't the correct measures taken to incorporate them as they were and allow them to be as they were.

Appendix B
Interview with Roman

Johanna Isaacson: How did you first get involved with the Occupy movement?

Roman: I was there at the initial meetings before Occupy Oakland. After a summer of Bay of Rage and anti-police marches, Occupy San Francisco came into existence following after Occupy Wall Street in NYC. I would say there was somewhat of an impetus from San Franscisco to Oakland to initiate something that would not simply mirror Occupy Wall Street but concern Oakland in its singularity and in relation to its unique history in struggle, both from decades before and the most recent series of events (Oscar Grant, student stuff, Bay of Rage, etc.).

JI: Where did you participate in the Occupy movement?

R: Oakland.

JI: How would you describe the physical space you occupied?

R: Most of the time before the encampment started, I thought of the front lawn of City Hall as really sterile, empty, and heavily regulated. There would be folks hanging out once in awhile, high school kids or older folks, or younger guys listening to hip hop and smoking weed, but other than that the large expanse of the lawn was unoccupied. The large buildings surrounding the space additionally made detracted from the space, these buildings being businesses and administrative buildings. While you could hang out on the lawn, and sometimes I did, it just didn't feel all that welcoming, especially considering that it was supposed to be a public space, there were barely any people around, and socializing with random people would of course be impossible, there was no need to. It was just a place to walk through or to stop by, not really hang out for an extended period of time. I think that the expanse of the space along with the huge buildings surrounding it really made it feel bigger than it actually was.

JI: What changes did you see in that space during the occupation?
R: The space almost felt like it shrunk down due to the amount of people, tents, and other constructions that filled up the area. It turned into a 'city within the city'; there was the kinda 'entrance' on 14th and Broadway, with food tent, supplies, library, and miscellaneous other aspects, hay was everywhere to soak up the water from the grass because it had recently rained, tents were everywhere else, with walkways made of wooden planks commandeered from warehouses criss-crossing the landscape, it felt really cozy and inviting, and the organic, spontaneous organization of space (not 'organized' in any sense, things were constantly moving around and people would fit miscellaneous other things onto the plots of grass where possible) brought up a feeling of something that was *alive*, something you didn't feel when the plaza wasn't occupied (yeah, I think it would be correct to say that the plaza felt "dead").

There was an openness to the space, where you could freely interact with folks, there was something about it being 'yours/ours' but not in the sense of property, it's because it was a living creation that there was this sense of belonging, that one was actively molding the space and whatnot. Also the sense of time was incredible. Those few weeks, talking to so many people, participating in workshops or helping with the library and hanging out generally during the day made time feel as if it was non-existent, beside having to go to work or run an errand. But the fact that the space was there made time outside of the space feel different, because you knew that it existed, and that it was there, and that it could potentially spread outside of the confines of that space. Time felt like it stretched on and on, like you were living every moment, as if you were fully present. Other people remarked upon this feature, this feeling of timelessness, that it was about purely existing at that moment. I don't know how to precisely describe it but it was the most intense, joyous affective experience I have ever felt.

Additionally, there was definitely a feeling of immense possibility, and that the finite limits of one's body was not limited at all, considering the mass of other people around and the ecstasy that was around. I mean, not to be overly positive, there were definitely some points were internal tensions existed and people would brawl and whatever, but even so, people knew that people had each other's backs, and you felt good about that. It is probably the density of the space, contrary to how Oakland is actually laid out, spread far apart, streets are big, largely suburban, ex-urban space and the gentrified areas are overall unpleasant (and too white, not to take it there, but just being honest). The fact that so many people were out in that area made it feel like you were in another world, and coming to it everyday just made that seem all the more real, as if the temporality were being disconnected from the regular depressing rhythm of normality. Again, the whole thing with how the space felt like it was 'ours' so there was definitely an investment in holding it down against the pigs.

I can't emphasize the aspect of time enough though, and for me at least, the disorganization of ideas and thoughts about what "I" was doing in that space, as if they were being distorted and scrambled or something, which was confusing having a political perspective with certain preconceptions, but overall really good. You definitely saw a lot more people open up, talking to some homeless folks, especially this one guy who I will name "D", there was definitely a lot of effusion of energy and the desire to spread the encampment to other parts of the city (and it even did, to Snow Park near Lake Merritt), and talking about strategic and tactical considerations about where we were going, what we were doing, etc., etc.

Looking back now, it really felt like we were on the brink of something else entirely; all the activity that was happening within that space, and activity that was being done together, collectively,

seemed like it was preparing for something huge. But not in the sense of a 'first step' in a sequence, because the activity that was happening in the camp was irreducible towards some outside goal; people were just getting together and doing stuff and in a way that clarified things, made things a bit more determinate. Banning cops from the space was a part of how people knew that this was different, because people didn't want to deal with them, they didn't want cops being a mobile force criss-crossing the spatial reality that had been set down and continually worked by people there. And that's part of the reason why so many different people, from homeless people to students to kids from the nearby hood to juggalos came together; it was about mobility through space without being hassled, even though it was a fixed space.

JI: What concrete practices or events did you take part in?

R: At the initial meetings. Part of the organizing committee for setting up the camp and its initial layout (but this kinda organically happened too when the camp got underway). Part of the first few nights and other nights, of "security", which was just staying up really late and keeping watch with other people for cops and to alert people if the cops were gonna raid. Helped with the library, printing a lot of pamphlets and bringing books. Helped with kitchen and some BBQs that happened throughout the camp. Organized some Fruitvale high school kids have a speakout against the OPD Gang Injunctions. Printed/distributed a bunch of different fliers, for practical/tactical considerations of the encampment. Helped initiate the Building Reclamations Committee (an attempt to bring together people to circulate information for occupying empty buildings for housing). Helped with the initial proposal for the Nov General Strike, drafting proposal. Anti-capitalist demo on the day of GS. Port shutdown, etc. Then there are other things but will leave those unsaid.

JI: In getting involved, what did you hope to accomplish?

R: I honestly had no expectations initially. I just wanted to see

something, anything, happen. Something that would articulate in its own organic way, the anger, frustration and anxieties of living in this horrible world.

JI: In what ways did your participation fulfill your expectations? In what way did it fall short?

R: I think that the single question that was posed to me is the role of the 'active minority' or those with a theoretical conscious-ness, a shared (anti-)political perspective. I saw myself, along with others of like-minded disposition, as a conscious fraction of the proletariat, but not as one that would 'lead' in any way, or could do so for that matter. What I do think is that there should have been a wider circulation of ideas within these moments that would correlate with the social and material practices that were being generated within the moment. There were definitely points where I questioned a lot of presuppositions in relation to 'militant identity' and its role in relation to the struggles that I was participating in, and how to overcome the ideological nature of these identities that would be purely ideological and maybe in some ways somewhat harmful to the elaboration of the organic dynamic of the movement. But I think that would have been impossible considering the vast heterogeneity of the movement, which I think was precisely its dynamic, how heterogeneous it was.

JI: How would you describe your political philosophy or affiliation?

R: Communist, but to be more specific, a communiseur (as in the communisation tendency).

Appendix C

Statement on the Occupation of the former Traveler's Aid Society at 520 16th Street

Last night, after one of the most remarkable days of resistance in recent history, some of us within Occupy Oakland took an important next step: we extended the occupation to an unused building near Oscar Grant Plaza. We did this, first off, in order to secure the shelter and space from which to continue organizing during the coming winter months. But we also hoped to use the national spotlight on Oakland to encourage other occupations in colder, more northern climates to consider claiming spaces and moving indoors in order to resist the repressive force of the weather, after so bravely resisting the police and the political establishment. We want this movement to be here next spring, and claiming unused space is, in our view, the most plausible way forward for us at this point. We had plans to start using this space today as a library, a place for classes and workshops, as well as a dormitory for those with health conditions. We had already begun to move in books from the library.

The building we chose was perfect: not only was it a mere block from Oscar Grant Plaza, but it formerly housed the Traveler's Aid Society, a not-for-profit organization that provided services to the homeless but, due to cuts in government funding, lost its lease. Given that Occupy Oakland feeds hundreds of people every day, provides them with places to sleep and equipment for doing so, involves them in the maintenance of the camp (if they so choose), we believe this makes us the ideal tenants of this space, despite our unwillingness to pay for it. None of this should be that surprising, in any case, as talk of such an action has percolated through the movement for months now, and the Oakland GA recently voted to support such occupations materially and

otherwise. *Business Insider* discussed this decision in an article entitled "The Inevitable Has Happened."

We are well aware that such an action is illegal, just as it is illegal to camp, cook, and live in Oscar Grant Plaza as we have done. We are aware that property law means that what we did last night counts as trespassing, if not burglary. Still, the ferocity of the police response surprised us. Once again, they mobilized hundreds of police officers, armed to the hilt with bean bag guns, tear gas, and flashbang grenades, despite the fact that these so-called "less-than-lethal" weapons nearly killed someone last week. The city spent hundreds of thousands of dollars to protect one landlord's right to earn a few thousand every month. Why is this? Whereas the blockade of the port – an action which caused millions of dollars of losses – was met with no resistance, the attempt to take one single building, a building that was unused, was met with the most brutal and swift response.

The answer: they fear this logical next step from the movement more than anything else. They fear it because they know how much appeal it will have. All across the US thousands upon thousands of commercial and residential spaces sit empty while more and more people are forced to sleep in the streets, or driven deep into poverty while trying to pay their rent despite unemployment or poverty wages. We understand that capitalism is a system that has no care for human needs. It is a system that produces hundreds of thousands of empty houses at the same time as it produces hundreds of thousands of homeless people. The police are the line between these people and these houses. They say: *you can stay in your rat-infested park. You can camp out here as long as we want. But the moment that you threaten property rights, we will come at you with everything we have.*

It is no longer clear who calls the shots in Oakland anymore. At the same time as OPD and the Alameda County Sheriffs were suiting up and getting ready to smash heads and gas people on 16th St, Mayor Quan was issuing a statement that she wished to

speak to us about returning the building to the Traveler's Aid Society. It is clear that the enmity between the Mayor and the Police has grown so intense that the police force is now an autonomous force, making its own decisions, irrespective of City Hall. This gives us even less reason to listen to them or respect the authority now.

We understand that much of the conversation about last night will revolve around the question of violence (though mostly they mean violence to "property," which is somehow strangely equated with harming human beings). We know that there are many perspectives on these questions, and we should make the space for talking about them. But let us say this to the cops and to the Mayor: things got "violent" after the police came. The riot cops marched down Telegraph and then the barricades were lit on fire. The riots cops marched down Telegraph and then bottles got thrown and windows smashed. The riot cops marched down Telegraph and graffiti appeared everywhere.

The point here is obvious: if the police don't want violence, they should stay the hell away.

Appendix D

Excerpts from Open Letter to
the General Assembly of Occupy Detroit

Detroit is a Movement City. Detroiters have been organizing resistance to corporate greed and violence for nearly a century, from the birth of the labor movement here in the 1920s to the radical black workers movements of the '60s to the current poor people campaigns against utility shutoffs that allow dozens of people to die each year. We have organized resistance to racism, sexism, homophobia, Islamophobia, ableism, and the criminalization of youth, to the systematic destruction of the environment in poor communities of color, to the dehumanization of people with disabilities, and so many other injustices – as they manifest in our daily lives and are reflected in practices that dictate access and distribution of resources, as well as policies at the local, state, and national levels.

Detroit is moving beyond just protest. Because we have survived the most thorough disinvestment of capital that any major U.S. city has ever seen; because we have survived "white flight" and "middle class flight," state-takeovers, corruption, and the dismantling of our public institutions; because the people who remained in Detroit are resilient and ingenious, Detroiters have redefined what "revolution" looks like.

Detroit is modeling life AFTER capitalism. In Detroit, "revolution" means "putting the neighbor back in the hood" through direct actions that restore community. It means maintaining public welfare programs for residents who are without income which protect said low income families from facing utility shut offs and homelessness. It means outlawing poverty in any form since the resources to prevent such a condition remain abun-

dantly available to this State. It means Peace Zones for Life that help us solve conflict in our neighborhoods without the use of police, reducing opportunities for police violence. It means food justice and digital justice networks across the city supporting self-determination and community empowerment. It means youth leadership programs and paradigm-shifting education models that transform the stale debate between charter schools and public schools. It means "eviction reversals" that put people back in their homes and community safety networks that prevent people being snatched up by border patrol. It means artists who facilitate processes of community visioning and transformation, and organizers who approach social change as a work of art. In Detroit, the meaning of "revolution" continues to evolve and grow.

Detroit will not be "occupied" in the same sense as Wall Street: The language of "occupation" makes sense for the occupation of the privately-owned Zuccotti Park on Wall Street. But this language of "occupation" will not inspire participation in Detroit and does not make sense for Detroit. From the original theft of Detroit's land by French settlers from Indigenous nations, to the connotations of "occupation" for Detroit's Arab communities, to the current gentrification of Detroit neighborhoods and its related violence – "Occupation" is not what we need more of. We will however participate in creating anew out of what remains in Detroit today.

Works Cited

Adorno, Theodor. *The Jargon of Authenticity*. Trans. Knut Tarnowski and Frederic Will Evanston. Ill: Northwestern University Press, 1973. Print.

Balakrishnan, Gopal. "Hardt and Negri's Empire." *New Left Review*. 5 September-October (2000) : Print.

Belsito, Peter and Bob Davis. *Hardcore California: A History of Punk and New Wave*. Berkeley, CA: Last Gasp of San Francisco, 1983. Print.

Benanov, Aaron. "Precarity Rising." *Viewpoint Magazine*. July 15 (2015): Web.

Benjamin, Walter. "The Author as Producer." *Reflections*. New York: Schocken Books, 1978. Print.

—. "On the Concept of History." *Selected Writings Volume 4*. Eds. Howard Eiland and Michael W. Jennings. Cambridge, Massachusetts; London, England: The Belknap Press of Harvard University Press, 2003. Print.

Berlant, Lauren. *Cruel Optimism*. Durham: Duke University Press, 2011. Print.

Bernstein Sycamore, Mattilda. "The Tourist Brochures in People's Hearts: a snapshot from Occupy Santa Fe." *We Are Many: Reflections on Movement Strategy from Occupation to Liberation*. Eds. Kate Khatib, Margaret Killjoy and Mike Mcguire Edinburgh Oakland: AK Press, 2012. Print.

Bey, Hakim. *TAZ: The Temporary Autonomous Zone, Ontological Anarchy, Poetic Terrorism*. New York: Autonomedia, 2003. Print.

Biafra, Jello. "Introduction." *Search & Destroy #1-6 The complete reprint*. . Ed. V. Vale. San Francisco: V Search Publications. 1996. Print.

Bikini Kill. "Affection Training." *Ladies Women and Girls*. Lookout Records, 2000. CD.

—. "Anti-Pleasure Dissertation." *The Singles*. Kill Rock Stars, 1998. CD.

—. "Carnival." *The C.D. Version of the First Two Albums*. Dischord Records, 1994. CD.

—. "Hamster Baby." *Pussywhipped*. Kill Rock Stars, 1994. CD.

—. "Thurston Hearts the Who." *The C.D. Version of the First Two Albums*. Dischord Records, 1992.

Bivens, Hunter. *Epic and Exile: Novels of the German Popular Front*. 1933-1945. Evanston: Northwestern University Press, 2015. Print.

Bloch, Ernst. *The Principle of Hope*. Cambridge, Mass: MIT Press, 1995. Print.

Boulware, Jack and Silke Tudor. *Gimme Shelter*. Penguin: New York, 2009. Print.

Bratmobile. "90s Nomad." *Ladies Women and Girls*. Lookout Records , 2000. CD.

Brecht, Bertolt. *Brecht on Theater: The Development of an Aesthetic*. New York: Hill and Wang, 1964. Print.

Breedlove, Lynne. *Godspeed*. New York: St. Martins Griffin, 2002. Print.

Brown, Adrienne, Maree Brown, Jenny Lee, Yusef Shakur, et al. "One step in Building the Occupy/Unify movement in Detroit." *Dreaming In Public, Building the Occupy Movement*. Oxford: New Internationalist Publications Ltd., 2012. Print.

Brown, Norman O. *Apocalypse And/Or Metamorphosis*. Berkeley: University of California Press, 1991. Print.

Burnett, Robert. *Absolutely Zippo Anthology of a Fanzine 1988-1998*. Berkeley: Benny & Son. Print.

Carlsson, Chris. *Nowtopia: How Pirate Programmers, Outlaw Bicyclists, and Vacant-Lot Gardeners Are Inventing the Future Today*. Oakland, CA; Edinburgh, Scotland: AK Press, 2008. Print.

—. "Some history of processed world," *Processed World*. Web. 3 Oct. (2007). Web.

Chambers, Iain. "Contamination, coincidence and Collusion: Pop Music, Urban Culture, and the Avant Garde." *Marxism and the Interpretation of Culture*. Eds. Cary Nelson and Lawrence Grossberg. Urbana: University of Illinois Press, 1988. Print.

Charles, Jenn and Bey Sharpe. Personal Interview. March 21 2010.

Chidgey, Red. "Riot Grrrl Writing." *Riot Grrrl: Revolution Style Now!* Ed. Nadine Modem. Black Dog Publishing. Print.

Chitty, Chris "Sex as Cultural Form: The antinomies of sexual discourse." Historical Materialism Conference Paper. CUNY Graduate Center. New York. 2010.

Chtcheglov, Ivan. "Formulary for a New Urbanism." *Situationist International Anthology*. Ed. Ken Knabb. Berkeley: Bureau of Public Secrets, 2006. Print.

Clark, Dylan "The Death and Life of Punk: the last subculture." *The Post-Subcultures Reader Oxford*. Eds. David Muggleton and Rupert Weinzierl. New York: Berg, 2003. Print.

Clover, Joshua. "Our Mad Worlds." *The Nation*. June 19, 2015. Web. 15 Feb. 2015.

—. "The Coming Occupation." *We Are Many: Reflections on Movement Strategy from Occupation to Liberation* Ed. Kate Khatib, Margaret Killjoy and Mike Mcguire Edinburgh Oakland: AK Press, 2012.

Cometbus, Aaron."60's Underground Press in Berkeley." *Despite Everything*. #34. Print.

—. "Berkeley Eyes on University." *Cometbus*. #34 in *Despite Everything* San Francisco, CA: Last Gasp, 2002. Print.

—. "On Zines." *Cometbus*. #28 (1987) : Print.

—. *The Loneliness of the Electric Menorah*. #51. Dirty Edition, 2008. Print.

Comstock, Michelle "Grrrl Zine Networks: Re-Composing Spaces of Authority, Gender , and Culture." *JAC* 21:2, Spring (2001): Print.

Connery, Christopher. "The End of the Sixties." *boundary 2*. Eds. Christopher

Connery and Hortense J. Spillers. 38 (2009): Print.

—. "The World Sixties." *The Worlding Project*. Ed. Rob Wilson and Christopher Leigh Connery. Santa Cruz: New Pacific Press, 2006. Print.

Corr, Anders. *No Trespassing!: Squatting, Rent Strikes, and Land Struggles*. Cambridge, MA: South End Press, 1999. Print.

Corrigan, Suzy. "Art, Politics and How One Grrrl Joined the Feminist Riot." *Riot Grrrl: Revolution Girl Style Now* Ed. Nadine Gorimer. Black Dog Publishing. Print.

Crabapple, Molly. "Movement Story." *We Are Many: Reflections on Movement Strategy from Occupation to Liberation*. Ed. Kate Khatib, Margaret Killjoy and Mike Mcguire. Edinburgh Oakland: AK Press, 2012. Print.

—. "Art After Occupy" *Jacobin Magazine*. 9 April 2013. Web. 7 Jan. 2015.

Crabb, Cindy. *Doris: An Anthology of Doris Zines from 1991-2001*. Portland, OR: Microcosm Publishing, 2005. Print.

—. "MMR Interview." *Maximum Rocknroll*. #236 December (2006): Print.

Crass, Chris. "San Francisco Urban Politics and Food Not Bombs." *Practical Anarchy*, 5, Jan., (2007): Web. 24 Feb. 2011.

CrimethInc "Beneath the Asphalt, the Paving Stones." *Rolling Thunder* #5 Spring (2008) : Print.

—. *Days of War Nights of Love: Crimethink for Beginners* Atlanta GA: CrimethInc Workers' Collective 2001. Print.

Crimethink, n.d.

—. "Fighting in the New Terrain: What's Changed Since the 20th Century." *CrimethInc. Ex-Workers Collective Online Reading Library*, n.d. Web. January, 20 2015.

—. "How Ethical is the Work 'Ethic:' Reconsidering Work and 'Leisure Time.'" *CrimethInc. Ex-Workers Collective Online Reading Library*, n.d. Web. January, 20 2015.

—. "Manifesto Part 72." *Harbinger 3*. n.d. Print.

—. *Recipes for Disaster*. CrimethInc. Ex-Workers Collective, 2012. Print.

—. "Report #1. One Prehistory of Auto Revision." *Hunter/Gatherer*. CrimethInc. Ex-Workers Collective: Olympia, n.d. Print.

—. "Report #2 Automobile Revision." in *Hunter/Gatherer*. CrimethInc. Ex-Workers Collective: Olympia, n.d. Print.

—. "The Illegitimacy of Violence, the Violence of Legitimacy." *CrimethInc. Ex-Workers Collective Online Reading Library*, n.d. Web. January, 20 2015.

—. "There is A Difference Between Life and Survival." *CrimethInc. Ex-Workers Collective Online Reading Library*, n.d. Web. January, 20 2015.

—. "There is a Secret World Concealed Within this One." *Harbinger 3*, n.d. Print.

—. "Tricks of the Tradeless" *Days of War Nights of Love: Crimethink for Beginners* Atlanta GA: CrimethInc Workers' Collective, 2001. Print.

—. *Work*. CrimethInc. Workers' Collective, 2011. Print.

D. "Vancouver- Occupation is a Fuckin Freak Show & notes for We, Antagonists." *Occupy Everything*. Ed. Aragorn! Oakland: Little Black Cart. 2012. Print.

Davis, Mike. *City of Quartz: Excavating the Future in Los Angeles*. London: New York: Verso, 2006. Print.

—. *Planet of Slums*. New York; London: Verso, 2007. Print.

Debord, Guy. "A User's Guide to Detournement." *Situationist International Anthology*. Ed. Ken Knabb. Berkeley: Bureau of Public Secrets, 2007. Print.

—. "Report on the Construction of Situations and on the International Situationist Tendency's Conditions of Organization and Action." *Situationist International Anthology* Ed. Ken Knabb. Berkeley CA: Bureau of Public Secrets, 2006. Print.

DeLeon, Richard Edward. *Left Coast City: Progressive Politics in San Francisco, 1975-1991*. Lawrence, Kan: University Press of Kansas, 1992. Print.

Denning, Michael. *The Cultural Front: the Laboring of American Culture in the Twentieth Century*. London; New York: Verso, 1996. Print.

D'Eramo, Marco. *The Pig and the Skyscraper: Chicago, a History of our Future*, London; New York: Verso, 2002. Print.

De Koven, Bernie. "Creating the Play Community." *The New Games Book*, Garden City, NY Dolphin Press, 1976. Print.

Edge, Brian. *924 Gilman: The Story So Far*. San Francisco: Maximum Rocknroll, 2004. Print.

Fanon, Frantz. *The Wretched of the Earth*. New York: Grove Press, 2004. Print.

Federici, Silvia. *Caliban and the Witch*. New York: Autonomedia, 2004. Print.

—. "Feminism and the Politics of the Common in an Era of Primitive Accumulation." *Revolution at Point Zero*. Oakland, CA: PM Press. 2012. Print.

—. "The Restructuring of Housework and Reproduction in the United States in the 1970s." *Revolution at Point Zero*. Oakland, CA: PM Press. 2012. Print.

Ferrell, Jeff. *Tearing Down the Streets: adventures in urban anarchy*. New York: Palgrave for St. Martin's Press, 2001. Print.

Ferretti, Fred. *The Great American Book of Sidewalk, Stoop, Dirt, Curb and Alley Games*. Workman Publishing company: New York, 1975. Print.

Fisher, Mark. Capitalist *Realism: Is There No Alternative*? Ropley, England; Washington, DC: O Books, 2009. Print.

Flanagan, Mary. *Critical Play*. Cambridge, Mass: MIT Press, 2009. Print

Flannigan, Tracy. *Rise Above: The Tribe 8 Documentary*. Wolfe Video, 2003. Film.

Ford, Laura Oldfield. *Savage Messiah*. Verso: London, 2011. Print.

Fox, Max and Malcolm Harris "Don't Stop Beliebing: A dialogue on pop music's prefiguration of the Occupy Protests." *The New Inquiry*. November

21, (2011): Web. 13 Feb. 2015.

Fraser, Nancy. "Behind Marx's Hidden Abode." *The New Left Review.* 86 London, 2014. Print.

—."Feminism, Capitalism, and the Cunning of History." *New Left Review.* 56 London, 2009. Print.

Freud, Sigmund. *The Uncanny.* London: Penguin, 2003. Print.

Fukuyama, Frances. "The End of History?" *National Interest* 16 (Summer 1989). Print.

Geertz, Clifford . "Deep Play: Notes on the Balinese Cockfight." *Play, Games and Sport in Cultural Contexts.* Eds. Janet C. Harris, Roberta J. Park. Champaign IL: Human Kinetics Publishers, 1983. Print.

Giroux, Henry A. "The Occupy Movement and the Politics of Educated Hope." *Truth Out.* 18 May, 2012. Web. 12 Feb. 2015.

Gitlin, Todd. "Occupy's Expressive Impulse" *Possible Futures.* May 21, 2012. Web. 6 Jan. 2015.

Gonzalez, Maya. "Communization and the Abolition of Gender" *Communization and its Discontents.* Ed. Ben Noys. London: Minor Compositions. 2013. Print.

—. "The Gendered Circuit: Reading the Arcane of Reproduction." *Viewpoint* 3, (2013). Web. 27 May 2014.

Goshert, John Charles. "Punk after the pistols: American music, economics, and politics in the 1980s and 1990s". *Popular Music and Society* Vol. 24.1 (2000). Print.

Graeber, David. "Concerning the Violent Peace Police." *N+1* Feb 9 (2012) : Web.

—. *Direct Action.* Oakland: AK Press, 2009. Print.

—. "Occupy Wall Street's Anarchist Roots." *Occupy Everything.* Ed. Aragorn. Oakland: Little Black Cart. 2012. Print.

—. *Possibilities: Essays on Hierarchy, Rebellion, and Desire.* AK Press: Oakland. 2007. Print.

—. "The New Anarchists." *The New Left Review.* 13 (January-February 2002): Web..6 March 2009.

Grogan, Emmett *Ringolevio; a life played for keeps* Boston: Little Brown, 1972. Print.

Guthrie, Woody. *Bound for Glory.* New York: New American Library 1983. Print.

Habal, Estella. *San Francisco's International Hotel: Mobilizing the Filipino American Community in the Anti-Eviction Movement.* Philadelphia: Temple University Press, 2007. Print.

Hanna, Kathleen. *My Life with Evan Dando, Popstar.* n.p., n.d. Print.

—. "Riot Grrrl Manifesto." *OneWarArt.* Web. July 13, 2010.

Harcourt, Bernard E. "Political Disobedience." *Critical Inquiry.* 39.1 (Autumn 2012) : Print.

Hardt, Michael, and Antonio Negri. *Empire*. Cambridge, Mass.: Harvard UP, 2000. Print.

Harker, David. *One for the Money: Politics and Popular Song*. London: Hutchinson, 1980. Print.

Hartman, Chester. *City for Sale: The Transformation of San Francisco*. Berkeley: University of California Press, 2002. Print.

Harvey, David. *Rebel Cities: From the Right to the City to the Urban Revolution*. New York: Verso, 2012. Print.

—. *The Condition of Postmodernity*. Oxford, New York: Blackwell, 1991. Print.

Hebdige, Dick. *Subculture: The Meaning of Style*. London; New York: Routledge, 1979. Print.

Hedges, Chris "The Cancer in Occupy." *Truthdig*. 6, Feb. 2012. Web. 6 Feb. 2013.

Huppauf, Bernd "Spaces of the Vernacular: Ernst Bloch's Philosophy of Hope and the German Hometown". *Vernacular Modernism: Heimat, Globalization, and the Built Environment*. Ed. Umbach, Maiken and Bernd Huppauf Stanford, CA: Stanford University Press, 2005. Print.

Invisible Committee. *The Coming Insurrection*. Los Angeles, CA: Semotext; Cambridge, Mass.:MiT Press, 2008. Print.

Isaacson, Johanna and Mark Paschal. "A House is a Home (with the help of bolt cutters): on occupation and its potentialities." *Viewpoint Magazine*. Web. 6 Dec. 2012.

Jameson, Fredric. *Brecht and Method,* London; New York: Verso, 1998. Print.

—. "Cognitive Mapping". *Marxism and the Interpretation of Culture*. Ed. Cary Nelson and Lawrence Grossberg. Urbana; Chicago: University of Illinois Press, 1984. Print.

—. *Marxism and Form*. Princeton, NJ: Princeton University Press, 1974. 232. Print.

—. "On the Power of the Negative." *Mediations: Journal of the Marxist Literary Group*. 28.1 (2014). Web. 18 Jan. 2015.

—. "Pleasure: A Political Issue." *The Ideologies of Theory*. Minneapolis: University of Minnesota Press, 1988. Print.

—. *Postmodernism, or The Cultural Logic of Late Capitalism*. Durham: Duke University Press, 1991. Print.

—. *Valences of the Dialectic*. London; Brooklyn, NY: Verso, 2009. 41. Print.

Joe. "Qualifying Statement." *Processed World*. 9. Print.

Jones, G.B. and Bruce LaBruce, *J.D.s*. Volume 4, Toronto, Canada, 1987. Print.

Jordan, John. "The Art of Necessity." *DiY Culture: Party and Protest in Nineties Britain*. Ed. George McKay. London; New York: Verso, 1998. Print.

Juno, Andrea. *Angry Women in Rock*. New York: Juno Books, 1996. Print.

Kamiya, Gary. "The Original Mad Men: What can OWS learn from a defunct French avant-garde group?" *Salon*. October 21 (2011): Web. 6 Jan. 2015.

Katsiaficas, George. *The Imagination of the New Left*. Boston, Mass.: South End Press, 1987. Print.

—. *The Subversion of Politics: European Autonomous Social Movements and the Decolonization of Everyday Life*. Oakland CA: AK Press, 2006. Print.

Kim, Richard. "The Audacity of Occupy Wall Street." *Dreaming In Public, Building the Occupy Movement*. Oxford: New Internationalist Publications Ltd., 2012. Print.

Knabb, Ken. "The Situationists and the Occupy Movements: 1968/2011." *Bureau of Public Secrets*. Web. 7 Jan. 2015.

Lane-Mckinley, Madeline. *After the 'Post-60s': A Cultural History of Utopia in the United States*. Forthcoming Dissertation.

—. "And We Mother Them Again": Motherhood at the Margins of the Movement" *Viewpoint Magazine*. Jan 2012. Web. 4 May 2012.

Largess, Koala. *We Are Many: Reflections on Movement Strategy from Occupation to Liberation*. Ed. Kate Khatib, Margaret Killjoy and Mike Mcguire. Edinburgh Oakland: AK Press, 2012. Print.

Lasn, Kalle. *Culture Jam*. New York : Quill, 2000, 1999. Print.

Leblanc, Lauraine. *Pretty in Punk*. New Brunswick, New Jersey, London: Rutgers University Press, 1999. Print.

Lefebvre, Henri. *Critique of Everyday Life Vol. 1*. New York; London: Verso, 2008. Print.

—. *The Explosion: Marxism and the French Revolution*. New York: Monthly Review Press, 1969. Print.

Kika and Traci. *Off the Map*. Olympia, WA: CrimethInc, 2000. Print.

Liboiron, M. "Tactics of Waste, Dirt and Discard in the Occupy Movement." *Social Movement Studies*. 11.3 (2012): Web. 16 Jan. 2015.

Lukacs, Georg. *History and Class Consciousness*. Trans. Rodney Livingstone. Cambridge Mass: The MIT Press, 1968. Print.

Lyle, Erick. *On the Lower Frequencies*. Brooklyn: Soft Skull Press, 2008. Print.

Marcus, Greil. *Lipstick Traces: A Secret History of the Twentieth Century*. Cambridge, Mass.: Harvard University Press, 1989. Print.

Marcus, Greil. "Liner Notes." *The Basement Tapes*. Columbia. 1975. Print.

Marcuse, Herbert. "The Affirmative Character of Culture." *Art and Revolution*. Ed. Douglas Kellner. Routledge: New York, 2007. Print.

Marder, Michael. "The European Union and the Rhetoric of Immaturity." *Aljazeera*. Feb 23., 2012. Web. 13 Jan. 2015.

Marx, Karl. *The Communist Manifesto. Karl Marx: Selected Writings*. Ed. David McLellan. Oxford: Oxford University Press, 2000. Print.

Massey, Jonathan and Brett Snyder. "Occupying Wall Street: Places and Spaces of Political Action." *Places*. September 2012. Web. 5 Jan. 2015.

Maximum Rocknroll, Iss. 311 (April 2009). Print.

McDonnell, Evelyn. "Queer Punk Meets Womyn's Music: *Tribe 8's* Performance at the Michigan Womyn's Music Festival." *Ms*. Nov.-Dec. 1994. Print.

McKay, George. "DiY culture: Notes towards an Intro." *DiY Culture: Party and Protest in Nineties Britain*. Ed. George McKay. London; New York: Verso, 1998.

McNeil, Legs and Gillian McCain. *Please Kill Me: The Uncensored History of Punk*. New York: Groove Press, 2006. Print.

McPhee, Josh. "A Qualitative Quilt Born of Pizzatopia." *We Are Many: Reflections on Movement Strategy from Occupation to Liberation*. Ed Kate Khatib, Margaret Killjoy and Mike Mcguire. Edinburgh, Oakland: AK Press, 2012. Print.

Melly, George. *Revolt Into Style: The Pop Arts in Britain*. London: Allen Lane, 1970. Print.

Nadia C. "Your Politics Are Boring As Fuck." CrimethInc Website. Web. Jan. 10 2010.

Neumann, Osha. "Occupy Oakland: Are We Being Childish? *Counterpunch*. February 3, (2012): Web. Jan. 5 2015.

Ninjalicious. "No Disclaimer." *Infiltration: The Zine About Going Places You're Not Supposed To Go*. May, 2010. Print.

Noland, Carrie Jaures. "Rimbaud and Patti Smith: Style as Social Deviance." *Critical Inquiry*. 21.3. (Spring, 1995): 581-610. Print.

Noys, Benjamin. *The Persistence of the Negative*. Edinburgh: Edinburgh University Press, 2010. Print.

—. "The Poverty of Vitalism (and the Vitalism of Poverty)" University of Brighton, 18 July 2012. Web. March 3 2015.

—. "The Recirculation of Negativity: Theory, Literature, and the Failures of Affirmation." *Stasis Journal*. May: 2012. Print.

O'Connor, Alan. *Punk Record Labels and the Struggle for Autonomy: The Emergence of DiY*. Lanham: Lexington Books, 2008. Print.

Peck, Abe. *Uncovering the Sixties: The Life and Times of the Underground Press*. New York: Pantheon Press, 1985. Print.

Peter. "Historicizing Violence: Thoughts on the Hedges/Graeber Debate." Ph.D. Octopus. Web. Feb. 5, 2015.

Polony, Antal. "Move-In Day." *Left Curve*. 36. (2012): Print.

Power, Nina. *One Dimensional Woman*. The Bothy, Deershot Lodge: Zero Books, 2009. Print.

Rasmussen, Debbie. "An Interview with Cindy Ovenrack Crabb." *Punk Planet* #75. 2006

Reitman, Ben. *Sister of the Road: The Autobiography of Boxcar Bertha*. New York: Amok Press 1988. Print.

Ross, Kristin. *Communal Luxury: The Political Imaginary of the Paris Commune*. London: Verso, 2015. Print.

—. *May '68 and its Afterlives*. Chicago: University of Chicago Press, 2002. Print.

—. *The Emergence of Social Space: Rimbaud and the Paris Commune.* Minneapolis: University of Minnesota Press, 1988. Print.

Rubin, Gayle. "The Traffic in Women: Notes on the 'Political Economy' of Sex." *The Second Wave: A Reader in Feminist Theory.* Ed. Linda Nicholson. New York: Routledge, 1997. Print.

Rushkoff, Douglas. "Think Occupy Wall St. is a Phase? You don't get it." CNN. com. October 5 2011. Web. 10 March 2015.

Sahlins, Marshall. *Stone Age Economics.* Chicago: Aldine-Atherton, 1972. Print.

Sharzer, Greg. *No Local.* Winchester: Zero Books, 2012. Print.

Sinker, Daniel. *We Owe You Nothing: Punk Planet: The Collected Interviews.* New York: Akashic, 2001. Print.

Situationist International. "Contribution to a Situationist Definition of Play." *Situationist International OnLine.* Web. 1 May 2009.

Skolnik, Jes. "The Forgotten Women of Punk: Spitboy's Michelle Cruz Gonzales on Riot Grrrl, Dystopias, and More." *Flavorwire.* August 4, 2015. Web. 15 Aug. 2015.

Slater, Josephine; Anthony Iles. "Interview with Laura Oldfield Ford." *Mute: Culture and Politics After the Net.* 25 Nov. 2009. Web. 7 Sept. 2013.

Sleater-Kinney. "I Wanna Be Your Joey Ramone" *Call the Doctor.* Chainsaw, 1996. CD.

Smith, Neil. *The New Urban Frontier: Gentrification and the Revanchist City.* London; New York: Routledge, 1996. Print.

Solnit, Rebecca. "Throwing Out the Master's Tools and Building a Better House: Thoughts on the Importance of Nonviolence in the Occupy Revolution." *Common Dreams.* November 14, 2011. Web. 2 Feb. 2015.

—. *Hollow City: the Siege of San Francisco and the Crisis of American Urbanism* London New York: Verso, 2000. Print.

Spahr, Juliana. "Non-Revolution." *Lana Turner Journal* Jan. 2015. Web. 2 Feb. 2015.

Standing, Guy. *The Precariat: The New Dangerous Class.* New York: Bloombury, 2011. Print.

Stark, James. *An Inside Look at the San Francisco Rock n' Roll Scene 1977.* San Francisco: RESearch, 2006. Print.

"Statement on the Occupation of the former Traveler's Aid Society at 520 16th Street." *Occupy California.* Nov. 9, 2011. Web. 1 Jan. 2012.

Stevens, Quentin. *The Ludic City: Exploring the Potential of Public Spaces.* London: New York: Routledge, 2007. Print.

Sunset, Johnny. "Dirtbag Kingdom." *Slingshot.* Winter, 2014. Print.

Surveillance Camera Players. *We Know You Are Watching.* New York: Southpaw Culture Factory School, 2006. Print.

"Taking Space: Beyond Adverse Possession: Seeking Revolution in Oakland's Squats" *Slingshot* Iss. 107 (Autumn). Print.

Taussig, Michael. "I'm so Angry I Made a Sign." *Critical Inquiry*. 39.1 (2012): Print.

"Text from a flier that was thrown from the roof of the occupied Municipal Courts building." *Occupy Everything*. Ed. Aragorn! Oakland: Little Black Cart. 2012. Print.

Thistle, Susan. *From Marriage to the Market*. Berkeley: University of California Press, 2006. Print.

Thompson, Stacy. *Punk Productions: Unfinished Business*. Albany, NY: State University of New York Press, 2004. Print.

Thompson, AK. *Black Bloc, White Riot*. Oakland: AK Press, 2010. Print.

Thomson, D. "Jump City: Parkour and the Traces." *South Atlantic Quarterly*.107.2 (2008): 251-263. Print

Toscano, Alberto and Jeff Kinkle. *Cartographies of the Absolute*. London: Zero Books. 2015. Print.

Tribe 8. "Butch in the Streets." *Fist City*. Alternative Tentacles, 1995. CD.

, VSan Francisco: V/Search, 1996.

Re/Search Publications, 1999

Van Deusen, David "The Emergence of The Black Bloc and The Movement Towards Anarchism: 'Get Busy Living, Or Get Busy Dying.'" *The Black Bloc Papers*. Ed. Xavier Massot and David Van Deusen. Shawnee Kansas: Breaking Glass Press, 2010. Print.

Walker "An Appetite for the City" *Reclaiming San Francisco* Ed. James Brook, Chris Carlsson, and Nancy J. Peters. San Francisco: City Lights, 1998. Print.

Wark, McKenzie. *A Hacker Manifesto* Cambridge: Harvard University Press, 2004. Print.

—. *The Beach Beneath the Street*. London: Verso, 2011. Print

—. "This Shit is Fucked Up and Bullshit." *Theory and Event*. 14.4, 2011. Print.

Weeks, Kathi. *The Problem with Work: Feminism, Marxism, Antiwork Politics, and Postwork Imaginaries*. Durham: Duke University Press, 2011. Print.

Williams, Evan Calder. "Pseudo-cinema." *Left*. Summer 2013. Web. 6, Nov. 2013.

Wilson, Rob. "Spectral City: San Francisco as Pacific Rim City and Counter-cultural Contado." *Inter-Asia Cultural Studies*, 9.4, (2008): 584. Print

X, Sasha. "Occupy Nothing: Utopia, History and the Common Abject." *Mediations: Time and the Labor of the Negative*. 28:1 Fall (2014). Web. 14, Dec. 2014.

Zukin, Sharon. *Landscapes of Power: from Detroit to Disney World*. University of California Press: Berkeley, 1991. Print.

Acknowledgments

This book was completed because of the infinite generosity, brilliance and what Bertolt Brecht calls the "militant optimism" of many people. Hunter Bivens, Chris Connery, Maya Gonzales, Madeline Lane-McKinley, Ben Noys, Kenan Sharpe, and Rob Wilson have been staunch allies in the battle to order my thoughts. Also thanks to family, mentors and friends Gopal Balakrishnan, Cara Baldwin, Aaron Benanav, Pat Caball, Joseph Carter, Steve Carter, Sarika Chandra, Chris Chen, Sean Connelly, Dylan Davis, Zina Denevan, Alex Day, Mona De Sure, Mario Diaz-Perez, Rebekkah Dilts, Chris Dixon, Kendra Dority, Erin Ellison, Barbara Epstein, Rachel Fabian, Dion Farquhar, Keegan Finberg, Jared Gampel, Camilo Gomez, Justin Hogg, Eric Isaacson, Earl Jackson, Jessica Jacobs, Katie Lally, Marsh Leicester, Patrick Madden, Kyle Lane-McKinley, David Lau, Laura Martin, Alexei Nowak, Jeb Purucker, Bali Sahota, Emmanuelle Salgues, Lisa Sprinkle, Dick Terdiman, Alberto Toscano, and Evan Calder Williams. I'm grateful to Tariq Goddard for his confidence in and help with the project. The book could not have been written without the inspiration I get from the work of Fredric Jameson. *The Ballerina and the Bull* is dedicated with utopian love to Chris Chitty and Tuli Lane-McKinley.

Repeater Books

is dedicated to the creation of a new reality. The landscape of twenty-first-century arts and letters is faded and inert, riven by fashionable cynicism, egotistical self-reference and a nostalgia for the recent past. Repeater intends to add its voice to those movements that wish to enter history and assert control over its currents, gathering together scattered and isolated voices with those who have already called for an escape from Capitalist Realism. Our desire is to publish in every sphere and genre, combining vigorous dissent and a pragmatic willingness to succeed where messianic abstraction and quiescent co-option have stalled: abstention is not an option: we are alive and we don't agree.